THE MAN

BEHIND

THE NOSE

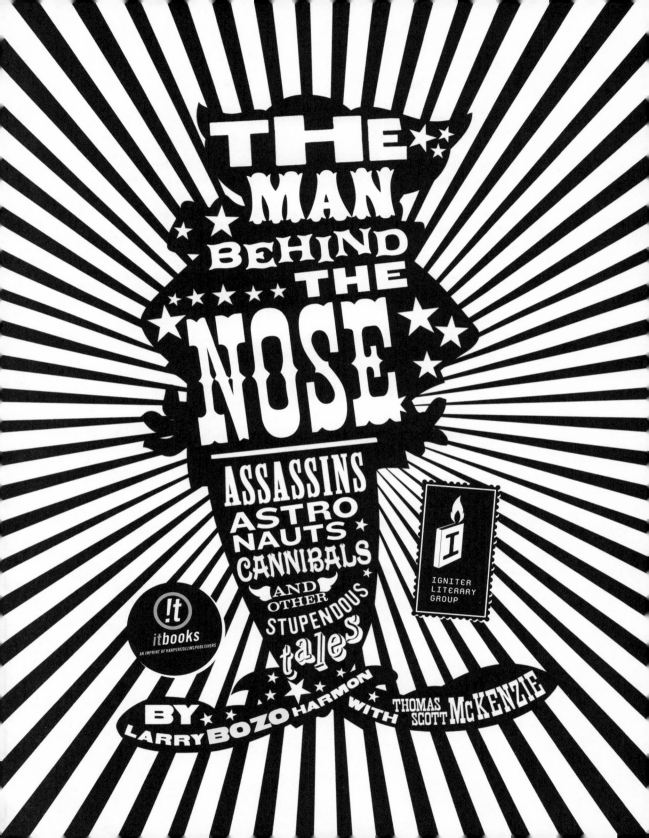

FIRST EDITION

Design: TJ RIVER & BAHIA LAHOUD at Meat and Potatoes, Inc.

· ·

LIBRARY OF CONGRESS CATALOGING-IN-PUBLICATION DATA

Harmon, Larry.
 The man behind the nose / Assassins, astronauts, cannibals, and other stupendous tales / by Larry "Bozo" Harmon; with Thomas Scott McKenzie. -- 1st ed.
 p. cm.
 ISBN 978-0-06-189647-7
 1. Harmon, Larry. 2. Clowns--United States--Biography. I. McKenzie, Thomas Scott. II. Title.
GV1811.H29A3 2010
791.3'3092--dc22

 2010006741

· ·

10 11 12 13 14 DIX/WC 10 9 8 7 6 5 4 3 2 1

To Susan—my wife, my business partner, my best friend,
and my constant companion.

And to the millions of fans around the world, kids of all ages,
who understand the importance of laughter.

Remembering a man's stories makes him immortal.

—Daniel Wallace, *Big Fish: A Novel of Mythic Proportions*

CONTENTS

FOREWORD

s writers, we've been lucky enough to meet many of our heroes. After a while, we even started to get used to it. But when it came time to meet Larry Harmon, we became nervous all over again. After all, he wasn't just a hero; he was an icon.

Like millions of other people, we grew up with Bozo the Clown. Since his first appearance on TV in the 1950s, and for every decade afterward, he has held a virtual media monopoly on clowndom. Practically every famous clown since, from Ronald McDonald to Krusty the Clown, would not exist without him.

With his flaming red wings of hair, bulbous red nose, enormous ruby smile, and machine-gun chuckle, Bozo was not only the archetypal clown, but also one of the only full-grown adults who understood children. He didn't talk down to them, expect them to act like adults, or force education down their throats. He simply was one of them. And, for that, children loved him.

When we first sat down with Larry Harmon to talk about a book based on his life—much of it centered on his portrayal and franchising of Bozo around the globe—we expected to hear a tale of hardship and decadence. We thought this would be a book about the frown behind the smile.

But it's not. Because Larry was Bozo. And Bozo was Larry. There was not a frown behind the smile, but simply another smile.

For three hours over dinner, Larry regaled us with stories of speaking with John F. Kennedy weeks before his assassination; of running for president as Bozo, during which three attempts were made on his life; of choreographing a dance routine with Fred Astaire; of training for space flights at a military base; of decorating Clark Gable's house; of searching for the cannibals of Papua New

..............

Guinea who were suspected of consuming Vice President Nelson Rockefeller's son; and even more incredible tales.

Just when we began to believe he was making some of them up, he pulled out photographic evidence. And, sure enough, there was Bozo in full clown makeup in New Guinea with a tribe of cannibals.

As he spoke, Larry's face was red with enthusiasm, his energy boundless, his smile unceasing, his patience superhuman, and his perspective on life bright and sunny. We'd never met a happier, more energetic, more enthusiastic eighty-two-year-old.

On our birthdays, he left greetings on our answering machines in his Bozo voice, because he knew it would thrill us. And this wasn't unusual for him: anyone who recognized him—and even anyone who didn't—was treated to a full Bozo show. During that first dinner, the waitress constantly stopped at our table just to hear his stories. As long as he was making someone smile, Larry was complete. And so, in that moment, we told ourselves, when we grow up, we want to be just like Larry.

"He left this world a happier place than when he came into it," said the rabbi at his funeral a year after that first dinner. "How many people can you truly say that about?"

Some believe fresh air, exercise, and a balanced diet are the secret to a longer, healthier, happier life. Others believe in Botox and facelifts. We believe in Bozo.

And so it is with the hope of implanting a little bit of Bozo in your heart that Igniter offers you the incredible but true tales and smiling life philosophy of the world's most famous clown.

—NEIL **STRAUSS** & ANTHONY **BOZZA**
IGNITER BOOKS

HOWDY! IT'S YOUR OLD PAL BOZO. OR, IF YOU PREFER, YOU CAN JUST CALL ME LARRY.

I've spent fifty-plus years talking to children. And I've been lucky enough to meet hundreds of thousands of them years later as grown-ups. Some have lived fantastic lives full of accomplishments, while others have gotten lost along the way. And the difference between them is usually just one word. That word is *inspiration.*

Nobody ever told them that what they want can really happen if they are determined enough. They can run for president, train to

be an astronaut, perform as a musician, star in movies, be a real-life action hero, or make people laugh as an entertainer.

I know because I've done all those things. I've found a place in history and in the entertainment world, where I've been watched and loved by millions of people. I've done everything James Bond has done. But in a wig and makeup.

The headlines might have focused on Bozo, but that was still me, Larry, hoping to avoid becoming dinner in the jungle or trying to escape assassins. And if there's a me, then there must be a you. And if there's a you, then you can do it all too—and survive to tell the tale.

Personally, I don't understand how people get by without inspiration. I meet many folks who ask me, "Where can I find inspiration?"

And I answer: "A red nose. Because behind the humor of an entertainer, you will find a quality more valuable than anything money can buy: the truth."

"But how can I tell what's true in such a busy, confusing world?" they ask.

And I tell them: "You will always recognize the truth, because the truth stands all by itself."

So pick yourself up, dust yourself off, and unplug from all that noise—both around you and inside you. Kick off your shoes, take a deep breath, and pull up a seat next to your ol' pal Boz. You're an adult now. So I can tell you things I never dared to share when you were younger.

Let's start by talking about sex.

Yes, sex.

Because as long as there's sex, there are going to be kids. And as long as there are kids, there's going to be a world. And as long as there's a world, there's going to be a Bozo.

And this is Bozo's story. It is also my story. Now, it is your story.

And what a story it is . . .

THE MAN BEHIND THE NOSE • LARRY "BOZO" HARMON

PART I · The Early Antics

"You ain't heard nothing yet!"

DAD, MY BEST FRIEND, THE OLD TICKET TAKER IN THE MOVING PICTURE THAT CAME TO LIFE, PART 1,

I WAS HEADED FOR A WHITE LAB COAT AND STETHOSCOPE UNTIL A JAZZ SINGER IN MAKEUP POINTED ME IN A DIRECTION THAT WOULD LEAD TO A RED NOSE AND A WIG.

When I was born in Toledo, Ohio, I was very, very young *(Fig. 1A)*. My family spent time in Syracuse and Endicott, NY, and a couple other places. But Cleveland is where I grew up, so it's what I consider home.

Fig. 1A

I was living in the land of the kneecaps at the time. Little children, at that age, that's all the world is to them. It's just a forest of adult legs, furniture legs, and tree trunks as big as a fairy-tale giant's legs. So my father picked me up and put me on his shoulders as we walked to the picture show one Sunday afternoon to catch a re-release of a very important film. He loved movies and kept telling me this one was different— this was one of the first films with dialogue we could actually hear!

8

The movie theater was a grand palace of entertainment with ornate decorations and interesting architecture. The carpet was soft under my feet and the red velvet curtains seemed impossibly thick. I sank into my seat like an exhausted steelworker collapsing on a thick feather pillow and waited excitedly.

The Jazz Singer started silently at first, with words on the screen, like other pictures. But when the singing came out of the speakers, I was shocked. It seemed impossible, unworldly. What had these maniacs at a mysterious location called Warner Brothers in Hollywood conjured up? A caveman stumbling upon a fire or a native tribesman seeing a photograph for the first time couldn't have been more in awe than I was in that movie theater.

When Al Jolson *(Fig. 1B)* made his appearance in the film, I immediately wanted to be like him. He was slender with short black hair slicked tightly on his head. In the early days of film, the actors wore quite a bit of makeup, so Jolson looked pale, with dark eyes highlighted by eyeliner.

Fig. 1B

When he clasped his hands and sang the words, "Wonderful pals are always hard to find." I was amazed! That first song, "Dirty Hands, Dirty Face" was a slower number, but Jolson jazzed it up with exaggerated facial expressions and hand gestures. I had never seen anything like it, which in hindsight may not be saying much

since my entire existence on this planet was limited to less than sixty months.

Seeing and hearing Jolson speak in the film affected me, and not just because it was a technical marvel. As a boy, I struggled with a stuttering problem. I was working hard to overcome it and, of course, they didn't have speech therapists like they do now. It wasn't easy for me just to tell my teacher the answer to a math problem—and yet here was Jolson, entertaining a whole theater.

When the crowd in the film erupted in applause after Jolson finished the number, he smiled and said, "Wait a minute, wait a minute. You ain't heard nothing yet." The crowd pounded its silverware and refused to simmer down. "Wait a minute, I tell ya!" Jolson implored. "You ain't heard nothing!" And then he launched into a more up-tempo song. He swiveled his hips, danced, clapped his hands, snapped his fingers, and lit up the screen.

The rest of the movie went by in a blur. I felt like a starving, mangy dog wolfing down a rare steak. When Jolson wasn't on-screen, I pleaded for the movie to hurry up and get to a point where he would sing to me again.

Toward the end of the film, I watched in amazement as Jolson smeared himself with shoe polish. He rubbed the black goo all over his face, his ears, and the back of his neck, leaving only a space around his mouth. He then pulled a tight wig over his head. It was shocking how quickly he was able to use the gobs of makeup to transform himself completely. He covered his entire being. And suddenly it was like I was watching a different person.

During the period depicted in *The Jazz Singer*, many minstrel performers wore blackface on stage. Later, people came to view the custom with distaste as it reflected negative stereotypes about African Americans. But as a child in the twenties, all I knew was

that the makeup transformed Jolson and propelled his on-screen act to higher levels of excitement and emotion.

When he dropped to his knee and belted out "My Mammy," I couldn't get over what I was seeing. Here was this incredible showman singing a song to his momma, expressing the very sentiments I had for my own loving mother.

He was just like me, only about forty years older, with a lot more money in his pocket, an incredible entertainment career, and a heck of a lot more makeup on his face and ears.

I made my father sit through all the credits when *The Jazz Singer* ended. I couldn't read the words and I had no earthly idea what a sound engineer or a film editor was. I was just afraid that Jolson would come back on the screen and I didn't want to miss any possibility of seeing him perform. I refused to budge from my seat until the house lights came on and the theater staff started sweeping the aisles.

From that point on, I devoured newspapers and books for any reference to the "World's Greatest Entertainer," as Jolson was called. I was amazed by his stamina. I was captivated by stories about how he would perform to sold-out audiences for two or three hours. Then after all the encores and curtain calls, he would come out, sit on the edge of the stage, and say, "Listen everybody, I'm not sleepy and don't want to go home. How would you like to hear some more?" And then he'd sing for another hour.

When *Hallelujah, I'm a Bum* arrived at the local theater in 1933, my excitement quickly turned to heartbreak. Dad was working and Mom had to take care of my brother, who had the flu. It was a frigid winter day with snow covering the ground and I told my parents I was going sledding with my buddy Anthony, who lived down the street. Instead, we ran to the picture show where Jolson's new movie was playing. At eight years old, I didn't have an allowance or any job, so I was broke.

At the front door to the theater, we told the employee that we desperately had to use the bathroom. We stomped our feet and crossed our legs and pleaded with him, claiming our parents would punish us if we had an accident in our pants. Finally, he let us in. We were one step closer. But we still had to get past the ticket taker—an old man who terrified all us kids.

No one knew his name, because we couldn't bear to look at him long enough to read the tag on his uniform. He was tall with broad shoulders, but so thin that it seemed his bones would puncture the skin. He reminded me of a dead, withered tree in a haunted forest. The ticket taker had a stoop, and hunched over as if gravity was yanking him to the ground. His skin was so pale that you could almost see through it and I horrifically thought of all the times I'd seen his liver-splotched talons extending from the red sleeves of his suit to snatch a ticket from my hands.

Anthony was a real friend. He knew how important this movie was to me so he ran right up to the ticket taker, boldly grabbed that skeletal arm, and said he'd lost his parents. A true ham, Anthony pitched a fit in the theater lobby, sobbing and crying. As the ticket taker dealt with the chaos, I slipped under the velvet rope and into the darkened theater. Once I was safely sunken into one of those plush seats, I knew Anthony would break off his charade and dash out of the lobby. The old ticket taker would return to his post, muttering about spoiled kids in a gravelly voice that sounded like the troll *(Fig. 1C)* in the *Three Billy Goats Gruff* fairy tale.

Fig. 1C

As much as I loved seeing Jolson in *Hallelujah, I'm a Bum*, I did feel guilty about sneaking into the picture show without paying. So in the days and weeks following my caper with Anthony, I scraped and saved pennies and nickels until I had collected the cost of a ticket. Then I went down to the theater, slid the money under the glass at the window, and ran away.

Over the years, Jolson's trademark phrase, "You ain't heard nothing yet!" seeped into my identity. It was part tease, part threat, part advertisement, part introduction, and it represented how I wanted to live my life. It summed up how I wanted to explode into the world, make an impact, and be known. I also appreciated how the phrase was a personal challenge. Even if Jolson sang exceptionally well, he still wanted to top his own performance, to do even better. I imagined him coming out for each encore, saying, "You ain't heard nothing yet!" and then launching into an even higher level of showmanship. It was like punching through the gears in a sports car, each one faster and more powerful than the last. And in my own life, I was starting to realize that it was time to kick my entertainment transmission into gear.

If I had that sports car, I would have put that phrase on a bumper sticker. If I had a billboard, I would have posted it there. If I owned a building, I would have flown it on a flagpole. Shoot, if I were a Navy sailor in some far Eastern sea, I probably would have gotten it tattooed on my arm. At that time, during my childhood years in Cleveland, I never dreamed that I would hear Mr. Al Jolson say those words directly to me.

———— ⋅❦⋅ ————

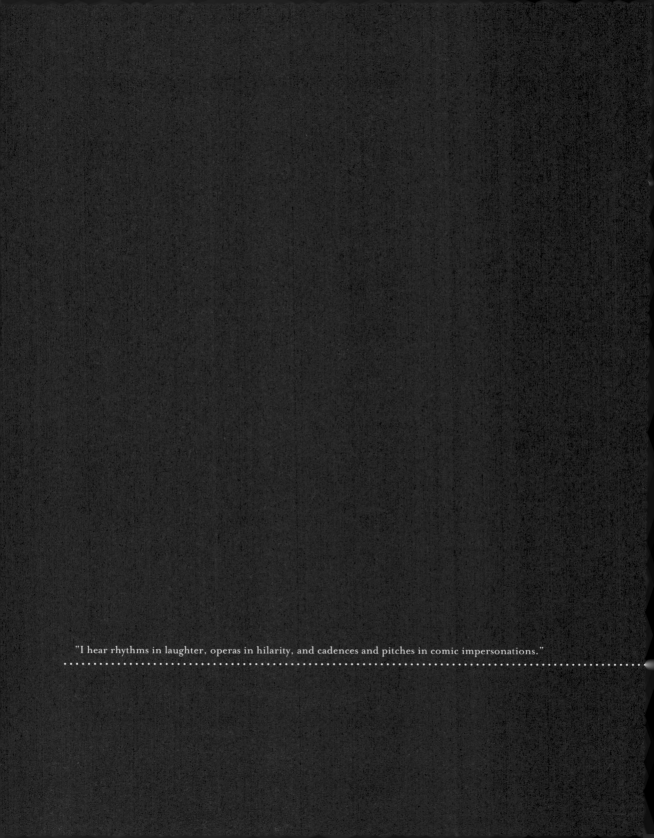

"I hear rhythms in laughter, operas in hilarity, and cadences and pitches in comic impersonations."

LIONEL HAMPTON, BUDDY RICH, GENE KRUPA, AND mr. WILCOXON IN A BOY AND HIS DRUMSTICKS

I'M SURROUNDED BY LAUGHTER. IF YOU'RE WITH ME, YOU'LL NOTICE GIGGLING, CHUCKLING, LAUGHING, SNICKERING, AND CACKLING. THOSE SOUNDS OF JOY ARE LIKE MUSIC TO ME, SYMPHONIES OF HAPPINESS.

I hear rhythms in laughter, operas in hilarity, and cadences and pitches in comic impersonations. I hear the beat of my shoes when I dance. And that makes perfect sense since music was one of my biggest passions. Certainly, until I saw *The Jazz Singer*, it was the first serious outlet for my entertainment ambitions.

As a small child, I dragged all my mother's pots and pans out of the cupboards and pounded on them, which, I suppose, many children do at some point. But as I got older, my pretend drum kits in the kitchen became more elaborate.

When I was six years old, I snuck a couple of Mom's butcher knives out of the drawer. They were longer and more drumstick-like than spoons, and I liked the *ting* they made when I struck things with them. I put together a wooden breadboard, a big metal mixing bowl, a cast-iron skillet, and an empty coffee can to form my first drum set. I was far too young to understand how legendary drummer Gene Krupa used the Chicago beats, four with one hand and a light rhythm with the other on the second and fourth beats, or why the courageous Chick Webb's steady 4/4 time was so

infectious, or the incredible rhythm of the drum wonder Buddy Rich. I would learn those things later. But even at that early age, I did know that when I banged on those pots and pans, people paid attention.

My parents always had the radio on in our house. My father, Joseph, did everything to support our family, toiling in numerous jobs from handyman to salesman. My mother, Eleanor, was exceptionally bright and always kept an office gig, even during the days when very few women worked outside the home as anything but a nurse or a schoolteacher. They worked long hours, so the radio was a way to relax.

In the evenings, I would grab a stack of *National Geographic* magazines, or occasionally the *Saturday Evening Post*, and flip through the pages while we all listened to Cleveland Indians games, FDR's fireside chats *(Fig. 2A)*, news broadcasts, and all kinds of music. Soon enough, I would forget about the magazines and lose myself in the radio. If I heard band music, I danced to the rhythm. If I heard an Indians game, I pretended to be the pitcher Pete Appleton throwing heat-seeking missiles from the mound. If I heard a politician's speech, like President Roosevelt, I imitated his voice and speech patterns.

Fig. 2A

We had an Italian man named Donadini who came to the house every few days to sell vegetables. He was tall and slender and wore his black hair closely cropped. I listened to him take my mother's orders and—to my childish ear—it seemed like I just had to add

an *a* on to the end of any word to make it Italian. I tried to mimic what Donadini said. And when I started listening to opera on the radio, I tried to copy what they were saying by mangling the sounds and adding an *a*. Between these imitations and my teachers working diligently with me at school and at home, I eventually overcame my stuttering.

The time I spent impersonating people, however, paled in comparison to the long hours I spent pounding on those pots and pans in an effort to play the drums with my mother's cutlery. So a couple years later, my parents decided our family would be much safer if the butcher knives were left to the adults. They got me a pair of drumsticks and found a fantastic local percussion teacher named Charley Wilcoxon.

Wilcoxon gave lessons to local kids and to famous musicians alike. Rumor had it that he worked with legends like Lionel Hampton *(Fig. 2B)* and Buddy Rich *(Fig. 2C)* when they came to town. He wore wire-rimmed spectacles and favored a pipe. He wrote several books on drumming and rhythms, which are still considered required reading for percussionists to this day.

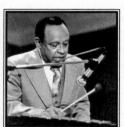
Fig. 2B

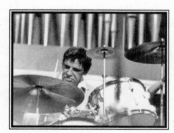
Fig. 2C

Every Saturday, I grabbed my sticks and walked to the streetcar stop down the block. Along the way, I turned the city into my orchestra. I pounded my drumsticks on banisters, brick walls, lightposts, and garbage cans as I skipped down the street. Streetcar

bells, honking horns, shouting neighbors, and soda-shop door chimes all punctuated my percussive symphony.

One winter morning, I looked out my window to see the whole world covered in a thin sheet of ice. After breakfast, Mom warned me to be careful going to my lesson because an ice storm had turned the entire city into a skating rink. While the thin coating of ice made it difficult for our neighbor, Mrs. Johnson, to reach her weekly bingo game, it added a crash to my city drumming. As I walked down the street, tapping out my usual trills and fills on the banisters and streetlights with my drumsticks, the ice broke with a tingle. Shards flew in the air, catching the sunlight and raining a kaleidoscope of rhythm.

On the streetcar, I stood at the back along the railing and drummed one of Mr. Wilcoxon's patterns: right-right, left-left, right-left-right-right, left-right-left-left. Then suddenly, instead of the chiming of the metal rail, I heard a wooden *snap*!

Only the broken nub of a drumstick remained in my left hand. I lunged toward the railing and saw the jagged edge of the stick's remainder in the street.

"Stop!" I screamed.

But the conductor's bell dinged and the streetcar lurched down the boulevard. As I watched my stick fade from sight, I was devastated. My family didn't have much money and I had no clue how much drumsticks cost, so I didn't know if we would be able to afford more. Besides, regardless of money, those sticks were precious to me, as dear and special as if they had been made from solid gold. I sank into a seat and wiped a tear from my eye. The loss seemed insurmountable, and I felt I would never be able to continue my music career.

That day, the ride to Mr. Wilcoxon's studio seemed to take all morning. The sun disappeared behind heavy gray clouds and a

frigid wind stirred off of Lake Erie. It turned cold and uncomfortable, but I hoped the ride would never end. I didn't want to have to face Mr. Wilcoxon and tell him I'd broken one of my drumsticks. I was afraid he would think I was irresponsible and destructive.

We finally reached my stop and I trudged up the steps to Mr. Wilcoxon's studio. I smelled his pipe and heard a teakettle whistling as I shut the door. The minute he looked at me, I lost it and started blubbering about the broken drumstick.

"It's okay, Larry," he said. "Drumsticks aren't expensive. You can get more."

His words failed to stop my tears. My parents worked hard to make ends meet, and I didn't want to burden them with additional costs for my music. The lessons were expensive enough.

Mr. Wilcoxon set down his pipe and leaned forward in his chair. "I'll tell you what we'll do. Give me the one stick you have left."

I reluctantly handed it over, afraid I'd be left with nothing.

"I've got a few extra sets lying around here. I keep them on hand because sometimes I have visitors who need them. Sometimes, a musician will stop by and his gear will be at the Palace or at his hotel. So he'll use these."

Then he handed me a pair of well-worn drumsticks. They were bigger than I was accustomed to—adult size—and had clearly been used extensively. But I was fascinated.

"You're ready for a man's drumsticks and these have served many others well. They'll help take you to the next level of playing. And we won't mention anything to your parents."

I gazed at the tiny nicks in the wood. What famous drummer had made those marks? Mr. Wilcoxon wouldn't give me any names; he just smiled when I asked. Maybe Gene Krupa *(Fig. 2D)*, maybe Buddy Rich, maybe other drumming greats. I felt like I had been given a magic wand of jazz rhythms, a talisman of the beat.

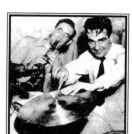
Fig. 2D

For the next hour, I hit every beat with the accuracy of a metronome built by Swiss watchmakers hanging on the wall in Henry Ford's factories. Powered by the mysterious adult drumsticks, I was precise, uniform, and unchanging, a testament to rhythmic efficiency.

That day, I learned that money doesn't allow one to accomplish things and find opportunities in this world. It's motivation and desire. Mr. Wilcoxon gave me those sticks not out of pity, but because he could tell I had a dream. And I may have been upset, but I wasn't going to let anything stand in the way of that dream. If I had to, I would have carved tree branches into new drumsticks.

Though I may have had a man's drumsticks, I still wasn't a real drummer. That day would come two years later, when I was eleven years old.

"We're going to do something a little different today," Mr. Wilcoxon said, rubbing his hands and smiling as I walked in for my lesson that Saturday. I followed him into the hallway and entered a room we didn't normally use during our sessions together.

Imagine that one year Santa Claus planned to give nothing but drums to children all over the globe. Now imagine that Rudolph's nose wasn't so bright, and Santa's sled turned over and spilled all that equipment. That's what the room in the back of Mr. Wilcoxon's studio looked like.

There were three men scattered among the gear. A man in a suit stood behind a vibraphone while two dark-haired men sat at drum sets. Since radio was the primary means of entertainment back then, I didn't know exactly who these musicians were. But I knew they were special: my heart jumped into my throat and my stomach plummeted as I felt a magical current surge through the room.

Mr. Wilcoxon put his hand on my shoulder.

"Larry, I'd like you to meet some friends of mine who can teach you a lot. This is Mr. Hampton, that's Mr. Krupa, and over there is Mr. Rich."

I dropped my drumsticks and yelped in shock. After all this time looking at those scarred drumsticks Mr. Wilcoxon had given me and wondering what musical geniuses had used them, legends Lionel Hampton, Gene Krupa, and Buddy Rich were now actually in the very same room as me!

They all said hello and Buddy Rich asked what I wanted to play.

"You, you want me to play with you?" I stammered.

"You'll do fine, Larry," Mr. Wilcoxon said. "What would you like to play?"

I mentioned the Duke Ellington tune "Mood Indigo." The musicians smiled, and we started tapping away on the equipment. It was an unusual sound—one kid, one teacher, and three legends all playing percussion with no other musical accompaniment. To someone standing outside the building, it probably sounded like a flock of woodpeckers going to work on a telephone pole. But to me, surrounded by my idols, it was the sound of heaven.

Decades later, in the seventies, my arms full of papers and bags slung over both shoulders, I boarded a flight to New York City. I stuffed everything in the overhead, collapsed into my seat, and

turned to ask the person next to me if they could lower the window shade because it was so hot in the plane. And only then did I realize that my neighbor was Lionel Hampton.

"Mr. Hampton," I started, "you have no reason to remember me. But many, many years ago, I took percussion lessons from Charley Wilcoxon in Cleveland, Ohio. One day when I was eleven, he brought me into his studio and you—"

"Don't tell me," Hampton interrupted. "You were that little boy!"

"I was indeed," I said as we shook hands. "That experience meant the world to me. Thank you for being so kind and generous to a young kid."

"I remember you had talent. What did you end up doing with your life?"

"I'm an entertainer," I said. Just then, the plane started to taxi down the runway and we had to get ready for takeoff. Once airborne, I looked over to Mr. Hampton to tell him about my work in the entertainment field. But the jazz legend was already fast asleep and I didn't want to wake him. For the kindness he had once shown me decades earlier, the least I could do was let Lionel Hampton get some rest.

"And that, ladies and gentlemen, was 'The Invincible Eagle March' by the March King himself . . ."

RALPH RUSH, KATYA THE ::::::: SPOTTER,

AND THE CLEVELAND HEIGHTS HIGH MARCHING BAND

Larry Harmon as Cleveland Heights High drum major

IN THE LITTLE DRY CLEANER WHO COULD

S THE YEARS PASSED, I BECAME EVEN MORE OBSESSED WITH DRUMS. BUT MY AMBITIONS CHANGED.

I became fascinated with marching bands. The New Year's Day radio broadcasts of the Rose Bowl in Pasadena, California, always described the University of Southern California Trojan Marching Band. I loved the inspiring songs they performed, the martial rhythms, the triumphant tunes. There seemed to be this massive army of musicians blasting out explosions of sound through my radio. And the ringleader of it all was the drum major. I had never even seen such a creature in person. But the broadcasters described his flashy outfit, his command of the performers, and his showmanship—and I was hooked.

In our house, a hallway led into the living room. As halftime approached for the football game, I would prepare myself at the end of the hall, and as the broadcasters gave the score and the teams headed to the locker rooms, I began my march. I pranced into the living room, high stepping, with my head thrown back, blasting the whistle and pumping a broomstick to the *brum-pa-pa-brruum-pa-pa* music while my parents clapped and cheered. After the halftime show was over, and the teams returned to the field, I lay on the couch and dreamed about leading the Spirit of Troy Marching Band into that massive stadium.

By the time I finished junior high, I was obsessed with becoming the drum major for my high school. I made plans, set goals, and devised strategies to achieve my dreams. I begged my parents to take me to football games and band performances so I could watch Alan Unger. He was the senior drum major at Cleveland Heights High School and I studied his every move. He was a darn talented musician. But I felt as though I had more showmanship in me, that I could be a bit flashier and entertain the audience better than he did. I couldn't just march out to the beat; I had to do more than that. I just *had* to.

The Cleveland Heights band director, Ralph Rush, was an intimidating man to aspiring musicians in the area. He was nice enough, but he was so famous, so influential in band music that kids trembled at the thought of speaking to him. Nevertheless, three months before starting my freshman year at the school, I scheduled a meeting with him so I could plead my case.

"Mr. Rush, I love this band. Every week for the past two years, I've watched your group perform. Every football game, every concert, every parade. I've seen them all. And I really admire Alan Unger and the work he's done for you. When does he graduate?"

"This is his senior year, so he'll be moving on to college after the season is complete," Mr. Rush replied. "We have some band competitions in the spring and that will be it."

"That's perfect. The timing works out great."

"What are you talking about?"

"I want to replace Alan Unger. I aim to be your next drum major."

He chuckled and leaned back in his chair. His brow wrinkled and I thought he was waffling between laughing and screaming.

"Son, you're not even in high school yet. You're sitting here, wasting my time, talking about joining a high school band when you're not even in the school yet?"

"Yes, sir. I want to get a head start."

27

"And do you even know how to be a drum major?"

"Not exactly. I've certainly studied the position and watched it closely. I have not been trained as one, no sir. But I've spent years studying with Charley Wilcoxon," I shouted as I rambled on. "I'm a great drummer and I know that I can—"

"Yes, that's wonderful," he said. "Wilcoxon is a superb teacher. But that still doesn't qualify you to walk in here and be a drum major. Do you know anything about conducting? About marching? Twirling a baton?"

"I can learn!"

"You've got ambition, I'll grant you that. But, to be frank, I hear these things all the time. Young men and women come into my office and tell me they will practice their instrument for six hours each night, they'll dedicate their entire weekends to marching, they'll rehearse and practice and work until their fingers fall off. And although I don't doubt they mean well, the harsh reality is that very few follow through on those promises."

He stood up from his chair and moved to the front of his desk.

"Now, here's how we're going to end this discussion. You must be a senior to be drum major. Exceptional juniors can do it in very rare cases. But you're not even in high school yet. When you enroll, you can attend band auditions in the fall. If you're really that good of a percussionist, you can earn a spot in the drum section. When you become a senior, then we can discuss your goal of being a drum major."

He opened the door for me to leave. I tried to hold my chin up as I left his office. I certainly respected his musical knowledge and his ability to lead a huge group of performers. But I wasn't going to take no for an answer. If I was willing to use butcher knives as drumsticks and a broomstick as a baton, I certainly wasn't willing to sit around and wait years and years for an opportunity to achieve my dreams.

I spent the next several weeks scheming for a way to learn the skills of being a drum major. Of course, this was long before the Internet or mail-order DVDs. Nowadays, if you want to learn how to fly a hot air balloon *(Fig. 3A)*, build a combustion engine *(Fig. 3B)*, or perform nuclear fission *(Fig. 3C)*, you just look up some website or call a 1-800 number to get educational materials. Back then, you had to scour newspapers, search libraries, and ask everyone you knew to find any information.

I discovered a music camp in nearby Cedar Point, Ohio, scheduled for late July. It was expensive and my parents couldn't afford to send me. I knew, if I really set my mind to it, I could find

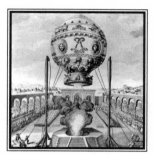

Fig. 3A

Fig. 3B

Fig. 3C

a way to get into that camp, just as I'd found a way to see those Al Jolson movies. But first, I wanted to talk to Mr. Rush again.

I scheduled another meeting, and told him I was going to attend band camp and practice all summer because I still wanted to try out for the drum major spot.

I begged for fifteen minutes, telling him how hard I was willing to work and how good I'd be as bandleader, until finally Mr. Rush laughed and pushed his seat away from the desk. He shook his head from side to side and smiled at me as he loosened his blue-striped tie.

"I don't know whether you are interesting or infuriating," he began, "but your perseverance is admirable. And I must say that I look forward to a time when you aren't pestering me. If you won't bother me any more, then yes, you can audition with the seniors."

I exploded out of my seat. "Thank you, Mr. Rush," I said as I shook his hand up and down, as if I were playing a rapid pattern on a snare drum. "You won't regret this." I ran from his office into the sunny spring day and let loose a holler of joy.

At this point, looking back over all these decades, it may seem odd that I was so obsessed with being a drum major. Millions of

children perform in high school marching bands and it just becomes a fond memory for them when they graduate. They go on to have productive lives, and maybe every now and then tell a few funny stories over coffee and dessert. But it wasn't something they obsessed over as a kid and it's not a big discussion point later in their lives.

For me, however, being a drum major was the first time in my life that I really, really wanted to do something. That I *needed* to do something. It combined so many of the passions I was developing: I loved music. I loved entertaining. And I wanted to be a leader.

Throughout my life, I've continued to be just as driven as I was in the office with Mr. Rush that day. With Bozo, with business endeavors, with personal relationships, I would not be told no. Human beings have an incredible capacity to do great things. And in this wonderful country of ours, we are given almost limitless opportunity. We can achieve whatever we want if we simply refuse to be deterred.

So, as a kid, I finally wore Mr. Rush down to the point where he would let me audition for the drum major spot in the fall with the seniors. Now I just had to earn enough cash to get to band camp so I could actually make good on my word to him.

Summer employment options were limited for a young person back then. But I had to do *something* to fund band camp.

My uncle owned a major dry cleaning business in New York State and I'd always listened to his work stories when we gathered during the holiday season. I figured I knew enough of the jargon to fake my way into a job. From there, I would simply work hard and learn quickly. That's the secret to being successful, really. If you work hard and learn quickly—you can do just about anything.

I walked a few blocks down the street to Cedar Main Cleaners and asked to speak to the owner. A red-haired woman told me he

spent all his time traveling between the central processing plant and different store locations, and he only stopped in once a week. She said he would probably be in Friday morning.

So I was there waiting on Friday, but he didn't show up. The lady told me he would be in Wednesday afternoon. But he wasn't there that afternoon either.

"Come back tomorrow morning," she said.

I was standing in the doorway when the lady opened for business the next day. I had to wait about four hours, but finally the owner came through the door.

He was very short, probably no more than 5'6". I was tall for my age and towered over the man. He was smartly dressed in a brown three-piece suit and had a closely groomed mustache. The red-haired lady introduced us and said his name was Mr. Lee.

"I know you have an opening at your central plant," I told him. "I heard you needed some help and I'm the perfect man for the job." That was a wild guess—I had heard no such thing—but if I could get him talking, then I could convince him to hire me.

"My uncle owns a big cleaner and laundry in New York and I know plenty about this business," I proclaimed, in spite of the fact that I knew next to nothing.

"I do need a spotter because we lost a great person the other day when he had to move to Topeka, Kansas, to care for an ailing relative," Mr. Lee said, speaking in great gulps of words, mashing together multiple sentences into one long spew of speech. "We have a nice Russian woman working in that position, but she's overwhelmed. So do you know what a spotter is?"

"Of course I do! I've been spotting since I was old enough to stand on my own two feet." I had no idea what functions a spotter performed, but I would scour the laundry for a spot, sleep on a

cot, take a shot, devise a plot, or get boiling hot if it helped me reach my goal.

"You'll have to be there at six in the morning. Can you do that?"

"I'll be there."

Mr. Lee didn't ask how old I was and I sure as heck wasn't going to tell him.

The following morning, I was at the plant by 5:30 A.M. I stood there waiting until this tall blond lady, who appeared to be in her mid-thirties, walked in carrying a cup of coffee.

"Good morning!" I greeted her. "You must be the famous Russian spotter."

"I am not sure how famous I may be, but yes, I am a spotter. And I am originally from Russia."

"Mr. Lee told me you were the greatest thing to happen to dry cleaning since the discovery of steam!"

"That is very good. I am not aware that he liked me that much." She started getting her workstation organized and prepared for a busy day.

"My uncle owns a laundry in New York. He taught me everything there is to know about spotting. But I don't say that to brag. I only say it because it's important to me to fit in—and even though I have experience, I'd like to see how *you* do it. I'm working for Cedar Main now and I want to do things the Cedar Main way."

I grabbed a pair of men's khaki pants that were short and wide, better suited to fitting around a kitchen stove than a human being.

"How would you work with these?"

She took the pants from my hand, grabbed a spray bottle, and misted the garment. "I take the pant like this, spray the cleaner here, rub it in with this tool, put a small amount of heat on it,

33

and boom, the spot is gone. Then I toss it in the bin to be cleaned."

"Wonderful! That's exactly how I would do it," I said. "It seems our styles are very similar."

We repeated this charade with every kind of garment and every kind of fabric. I asked how she would do it, watched her closely, and got a quick tutorial in working at a dry cleaner.

I did everything that Katya taught me. I always tried to beat her productivity. Not to make her look bad or embarrass the kind lady, but to prove my worth to the company. If she did twenty pairs of pants a day, I would strive for thirty or thirty-five. And my return rate was very low. Even though I rushed everything, nothing ever came back as a mistake. I was diligent and thorough, in spite of the speed. So after about a week and a half, Mr. Lee stopped by one afternoon as we were shutting down.

"It's picking up around here and I've heard great things about your performance," he said. "Our productivity has gone through the roof since you started."

We chatted a bit about how else I could help the company.

"How about driving for us? You can drive a truck, right?"

"Sure, that's nothing. Who can't?" I had never even been in a big, industrial vehicle before, but I figured I'd get the hang of it.

"One of our delivery drivers never makes his stops on schedule. He's always behind and customers get mad because their clothes aren't dropped off at the right time."

"Say no more, Mr. Lee. I'm your driver. I'll be done an hour before the workday is over. I'll get the clothes there, safely and early!"

He handed me a set of keys and pointed toward a delivery truck in the yard behind the building. After we closed and everyone left for the day, I went back to the plant, climbed the fence, and ran

around the building to where the truck was parked. I practiced driving that monstrosity until it was long after dark. By the time I finally went home, there wasn't much clutch left, but I had it licked.

Over the next few weeks, Mr. Lee kept giving me raises. I started at twenty cents an hour and eventually made my way up to almost seventy-five cents. I raced all over the neighborhood, taking corners like a bootlegger and punching it in the straightaways like a steam train striving to make up time.

"You're a good driver," Mr. Lee told me as I swept the floor one hot afternoon. I had finished all my deliveries, gassed up the truck, returned to the plant, and grabbed a broom to stay busy.

"I must admit that I'm losing my eyesight, which makes the missus nervous for me to drive. So I was wondering, why don't I give you my car and you pick me up each morning and drop me off in the evenings?"

Over the next few days, I made it a point to get to his house early—and have a cup of coffee and the newspaper waiting. He would read and sip his drink as I drove us to work. Eventually, I earned enough to pay my registration fee for band camp.

Mr. Lee didn't have any children, and I got the feeling he really liked me and appreciated what I was doing. One day as we pulled into the parking lot, he made me an offer.

"Larry, you're doing very well here because you've got drive, ambition, and a work ethic that can't be beat. So if you keep doing what you're doing and working hard, I'll send you to school to learn about the dry cleaning business. You have a great head on your shoulders and it'll do you a world of good to learn about the business side of things. You can come back after your schooling and have a future; you can work your way up and eventually become one of the owners here at Cedar Main Cleaners."

35

I swelled with pride. But I was also sad: Mr. Lee had been nothing but decent and honorable to me. He gave me an opportunity and taught me a great deal about being successful. I looked up to him like a father. Yet my dreams were still occupied by the sounds of music. We sat in the car as the dew burned off in the rising sun. Plant employees were arriving that morning as shopkeepers across the street rolled out their awnings.

"How old are you anyway, son?"

"Well, Mr. Lee, I sure am glad you didn't ask me that before now."

"Why? You have to be what? Eighteen or nineteen?"

I dropped my head and stared at the floorboard. "No, I'm fourteen."

"That can't be! There's no way you're fourteen."

I summoned up my courage and looked Mr. Lee straight in the eyes. "I appreciate everything you've taught me," I said. "I'm grateful for the opportunity. But you know all those times you heard me tapping a beat on the steering wheel?"

"Yes, you have a great sense of rhythm."

"That's my dream, sir. Music and entertaining! I hear it in my heart and I feel it in my bones. I can't get away from music. And, well, I took this job because I needed money for band camp. The truth is that I might as well give you my notice now, because I'm leaving in a couple of weeks. I don't want to leave you in a lurch, so I'll help you find someone new and I'll teach them and help transition into everything."

He looked shocked. Mr. Lee turned his head away from me. He cleared his throat and adjusted his tie. He stared out the car window. I was terrified that he would be mad at me for hiding my age, for leaving the job, or for declining his offer.

Finally, after several minutes, he faced me. "Larry, you've

done right by me and you always gave me a hard day's work for your pay. So I appreciate how you feel because it's good for a young man to have dreams, and I hope you succeed in your musical ambitions. But entertainment is a tough way to make a living since so few people ever succeed in it. You should have a backup plan."

"Well, I've always done well in my science classes and I really like helping people. So I figured I could become a doctor," I said. As a child, I had been impressed with our family doctor, with his pristine suits, black bag full of amazing implements, and ability to make a cough go away.

"Now, see, that's a much more reasonable goal. A challenge, but there are certainly more doctors in this world than Benny Goodmans. I'm not saying you shouldn't pursue music, but just be realistic about it. And if you ever change your mind about the cleaning business, I'll always have a place for you. I doubt you'll need it though, because if you do as well as you've done here, you'll go a long way in whatever you pursue."

The final two weeks at the cleaners disappeared quicker than a blast of steam as I raced to get everything done. I didn't want to leave Mr. Lee with a mess, so I made sure to handle all my outstanding tasks. On my last day, a sweltering Friday afternoon, everyone at the cleaners threw me a going-away party. Katya gave me a big hug and Mr. Lee handed me an envelope.

"You'll need a little extra spending money, so that's on behalf of everyone at Cedar Main Cleaners. It's our contribution to jump-starting your journey to stardom." They clapped and cheered as I walked out the door and headed home. I was flush with a feeling of accomplishment from my time at the cleaners and eager to begin my education at band camp.

The next day, my parents drove me to Cedar Point, a resort town on a peninsula in northern Ohio. Kids from all over the

state and the Midwest attended this band camp, and I was determined to learn more than all of them combined.

Though Mr. Lee's gift helped tremendously, I still needed some extra cash for food and expenses. So I got a job working as a busboy at the giant food service operation on the resort where they served between two thousand and three thousand people a day. As a busboy, I hauled dishes in and out, piling them in my bin until I could barely stagger to the back under all the weight.

When I wasn't working, I was taking lessons on music theory, marching routines, conducting skills, baton twirling, percussion, and every other thing I could possibly absorb. If they had offered a class on how to carve a bassoon out of ivory with a butter knife, I would have taken that as well. The woman in charge of the camp seemed to really like me and frequently let me conduct and lead the musicians.

On the final day of camp, we were playing on the lawn and running around barefoot. I had finished my stint as a busboy so I didn't have to work, but I dashed into the dining hall for a drink of water. They were slammed. It looked as if a horde of invading Mongols *(Fig. 3D)* had pillaged the room. Tables were piled high

Fig. 3D

with dirty dishes and incoming diners didn't have anywhere to sit. I couldn't just leave my old coworkers hanging, so I grabbed a bin and started bussing. After knocking out five or six tables, I raced

to the dishwasher to unload. I knew I shouldn't go in the back of the restaurant without any shoes on, but it was only for a moment because I was trying to help.

I turned the corner back near the dishwashing area and the floor was wet. I slid and my foot jammed into the metal leg of a workstation. I screamed in pain and dropped my bin of dishes.

The lady who ran the camp took me to the hospital. The doctors said I had torn a tendon in my foot and they put me in a cast. My parents came up to Cedar Point and collected me from the hospital before heading home.

That was the longest car ride of my life.

With my foot in a cast, that was it. It was over, buddy. No drum major. I wouldn't even be able to perform with the percussion section because I couldn't march. I had invested all this time, sweat, learning and desire into my dream and it wasn't going to happen.

"Darling, you can try out next year," Mom said. "If Mr. Rush was willing to let you do it as a freshman, he'll let you do it as a sophomore."

I didn't answer her. She meant well, but I couldn't see anything positive about the situation. At home, I went straight to bed but didn't sleep. I stared at the ceiling, brooding about how all my efforts were for nothing and that I would have to sit in the stands and watch the Cleveland Heights band perform with someone else in the spotlight.

Then the door opened. My father stood in the hallway with the family radio in his arms. "I figured you might have trouble getting to sleep," he said. "You can listen to this for a while to help you doze off."

He plugged in the radio, turned it on, patted me on the head, and closed the door.

Eventually, I reached that narrow, indefinable place between being asleep and being awake. An orchestral song came on the

39

radio that was full of ups and downs, like the waves in a turbulent sea. Images—maybe they were the dreams of a sleeping child, or just the fantasies of a frustrated and wide-awake boy—floated through my head. I saw myself, healthy and unencumbered by any cast, flying, swooping up and down in the air like a powerful hawk gliding on the wind currents. Whatever state I was in while listening to the song, I vividly recall being conscious when it was over.

"And that, ladies and gentlemen, was 'The Invincible Eagle March' by the March King himself, John Philip Sousa *(Fig. 3E)*," the overnight disc jockey said.

Fig. 3E

I had no idea what time it was. But I never slept again that night. Instead, I lay in bed, plotting and planning. That amazing song, the confidence it inspired, the idea of invincibility...

Cast or no cast, I would be the next drum major for Cleveland Heights High!

The next day, about a week before the audition, I went to see Mr. Rush. He was standing by the window in his office, enjoying a cool breeze when I hobbled in. He took one look at my foot and told me it was over.

40

"You're a nice person, Larry. And you're determined. I feel badly about your awful luck, but at least you can take some time to relax now. When your foot gets better, you can try out for next year's drum section. When you're a senior, we can discuss your aspirations to be a drum major."

"Mr. Rush, did you make me a promise?" I asked.

"Yes, I did. I said you could try out with the seniors if you would just leave me alone. But that cast on your foot makes the whole conversation pointless."

"Mr. Rush, do you honor your promises?"

"Of course I do! But this has nothing to do with—"

"I intend to be at those auditions. If I get the cast off between now and then, great. If not, I'll do it with all this plaster getting in the way. But I am going to be there and I am going to complete the audition. If I'm not good enough, then so be it. But I am not giving up now."

Mr. Rush laughed and said he looked forward to seeing me at the audition. "You're just crazy enough to make it work," he said, shaking his head as I left the office.

I woke before sunrise on the Saturday of the audition. I twirled my baton and conducted along with some records on the Victrola (*Fig. 3F*). Mom made a nice hearty breakfast of pancakes and fruit, but I was careful not to eat too much so I wouldn't be sluggish.

Fig. 3F

41

We pulled into the parking lot and I saw all kinds of people on the football field and in the stands. Mr. Rush had said drum major tryouts were limited to a select few upperclassmen, but, to me, it looked as if the entire marching band was on that field. And everyone must have brought their parents, siblings, and first, second, and third cousins to watch because the stands were jam-packed.

I hobbled onto the football field and my cast sank into the lush grass. The sun was high in the sky and it was already getting hot. Mr. Rush asked everyone to line up and, individually, we had to conduct a short composition by Aaron Copland. We were all relatively equal in that challenge.

Then we had to demonstrate our skill with the baton while completing a complicated marching pattern. The weight of my cast and the inability to bend my ankle made marching in proper rhythm difficult but not impossible. I tried to ignore the sweat running down my leg into the itchy cast while I demonstrated my command of the field, my flourishes with the baton, and my showmanship and energy. My injury hindered me in the most technical skills, but I hoped my passion was evident enough to balance out those shortcomings.

Even at that early age, I knew the importance of a climactic finish. I stomped toward the back of the end zone and did a backbend until my head almost touched the ground as I arched over the touchline painted on the field. Then I popped back up, took three giant strides, and hurled two batons as high in the air as I could. I marched under the goalpost, waved to the crowd, and, stomping in perfect rhythm, leaped into the air, then deftly caught the batons behind my back when they finally came down on the other side of the end zone, punctuating the climax of the song. In my brain, I knew my foot *should* hurt from the leaping and landing. But the fact is I couldn't feel a thing.

The crowd jumped to its feet and roared. Even my competitors in the auditions cheered. I could see Mr. Rush smiling.

The next day, my mother said Mr. Rush had phoned and wanted to see me in his office. I raced—as much as I could race in a cast—to the school.

"When do you get that cast off?" he asked.

"A couple of weeks."

"Well, if it's off by the start of school and our first band practice, then you've got the job. You may be the only freshman ever in the history of this school to become drum major. But you're the best thing I've seen!"

"You go be a doctor all right. But a doctor of laughter."

AL JOLSON

AND THE U.S. CALVARY IN

THE MOVING PICTURE THAT CAME TO LIFE

PART II,

THROUGHOUT MY TIME AT CLEVELAND HEIGHTS HIGH, I ALWAYS BEGGED MR. RUSH TO USE MUSIC FROM JOHN PHILIP SOUSA IN PERFORMANCES. SINCE THAT NIGHT WHEN "THE INVINCIBLE EAGLE MARCH" INSPIRED ME TO KEEP PUSHING IN MY QUEST TO BECOME DRUM MAJOR, I HAD BECOME COMPLETELY ENGROSSED WITH HIS MARCHES.

Whenever our band played "The Washington Post" or "The Stars and Stripes Forever," I experienced a surge of excitement and power. Sousa's marches made me feel like a confident general leading an army of talented musicians in a celebration of inspirational music.

During that time, Mr. Rush and I worked closely together. We became great friends and he was a tremendous inspiration for my musical career. He also shared my love of the University of Southern California. Although he was well respected by bandleaders in the Midwest, he wanted to get a job at USC. Whether he was a professor, part of the music department, bandleader—it didn't matter to him. He just had a dream that, coincidentally, involved the same institution that would soon figure so prominently in my own aspirations.

As I matured, however, going to medical school began to seem more and more realistic to me than entertaining. Although I loved

performing and drumming as a hobby, I realized what a long shot it was to become any kind of success in show business. Playing the lottery is a more practical career plan than playing Hollywood. So medicine, at least at that point, had become the path for me.

But like so many other men of the day, I had to put my higher education goals on hold during World War II. I vividly recall sitting with my parents in the living room and listening when President Roosevelt came on the radio to tell the country that Pearl Harbor had been attacked.

As the war effort ramped up and the draft kicked in, I watched more and more of my friends go off to the military. My high school marching band wanted to send these brave young men off with a tribute as a way to inspire them and thank them for what they were doing. So we accompanied the draftees down to the train station to perform and honor them. I led hundreds, maybe thousands of men down a parade route that would be the last they saw of Cleveland for a while—and for some, forever.

Eventually, when my time came to serve, it was during some of the bitterest fighting of the war, when the Nazis and the Japanese were on the move, and I wasn't completely convinced that I wouldn't end up being cannon fodder somewhere in Europe or the South Pacific.

I was supposed to go into the Air Force and work with the military band. But there was a mistake in the paperwork and instead I was sent to Fort Riley, Kansas, to train with the Army's horse cavalry *(Fig. 4A)*. Who would have ever dreamed we still used horses in combat in World War II? Nothing seemed like a worse way to evade machine guns and mortar fire than riding five feet in the air on the back of a four-legged, thousand-pound animal. What a crazy idea. That's a surefire way to get blown to bits all over the South Pacific, I thought.

47

Fig. 4A

A friendly military chaplain offered to help and requested that I be assigned as his assistant. But as petrified as I was, I declined the offer.

"There's a war going on and if my country needs me on horse-back, then I'll do it," I said.

"You realize the mortality rates for cavalry, right?" he warned. "Think about what you're doing, Larry."

But I knew I had to do my duty for the country whose prin-ciples of liberty and freedom I owed my life and happiness to. On the day my group was to depart, I didn't put on my band uniform. This time, I just wore my gray wool suit, which seemed to fit the gravity of the situation. Then I put on my drum major hat and met my bandmates at our usual spot. We gathered the other young soldiers and struck up the band.

We marched down the street, performing Sousa's "The Gladi-ator" and "The U.S. Field Artillery." Families and well-wishers lined the sidewalks, waving. Some women were crying, and men kept their handkerchiefs at the ready. Children darted in and out of the forest of adult legs, trying to get a good view of the parade. Everyone tried to put on a brave face. We were all scared to death but proud to be serving our country. In today's fractured times,

everyone has their own agenda, but back then, we were united and focused on fighting the good fight.

The band reached the train station near Terminal Tower and all the soldiers boarded as we wrapped up "Stars and Stripes Forever." I took off my drum major hat, handed it to the person next to me, stepped to the boarding platform, and turned to face the crowd.

I saw my parents standing to the right. Mom was wearing her favorite blue dress and Dad had on his most formal navy blue suit. My beloved marching band was lined up in front of me. I waved to them all one last time and stepped on to the train, bound for the induction center in Columbus. No longer a drum major, I was now a soldier.

I took my training seriously at Fort Riley because I fully expected to put those skills to use in combat. I loved working with the horses; they were such strong and interesting creatures. But I wasn't looking forward to trotting around on one while the bullets flew. At that time, the cavalry was transitioning from using horses exclusively to mechanized strategies. Most of us would not end up playing jockey with a machine gun, but I wasn't sure that trudging through the field on foot was a much better option.

When I told the man who met me at the base that I had a music background, he assigned me to bugler duty, even though I knew nothing about blowing a horn. So each night I stole a few minutes on the obstacle course after everyone was finished for the day to squawk some blasts out of the bugle. Eventually, I managed to get something remotely resembling "Reveille" and "Taps."

During breaks in my training, I tried to keep up with the rest of my music and entertainment skills. Over the wartime years, something like 125,000 soldiers trained at Fort Riley. Actor Mickey Rooney, fashion designer Oleg Cassini, and heavyweight boxing champion Joe Louis even spent time in those same barracks.

I managed to become the drum major of a marching band that performed when dignitaries and politicians visited. In that environment, the regimented, highly structured music of John Philip Sousa was tremendously appreciated, so I took every opportunity to perform it. Not only did the soldiers like Sousa's compositions, but I also felt like I was paying the great musician a fitting tribute. He had played such an important role in inspiring me to achieve my dreams. I felt somehow connected to him, as if I were an evangelist trying to spread the gospel of Sousa.

I also played in a couple jazz and swing outfits with other grunts, and also developed some stand-up comedy routines. If just one solitary soldier was looking for entertainment, I was there to provide it.

One day, a sergeant who worked with the marching band pulled me aside and asked me to perform in a show for the troops.

"Sure. I'd love to!" I replied.

"This is going to be a major production," he said. "Lots of bigwigs are coming in from Washington. We'll have a couple of high-ranking generals here. And they're bringing in some famous performers as well."

He didn't have to sell me. If I could get on a stage and under a spotlight, I didn't need any more incentive. But what he said next gave me goose bumps. "And Al Jolson is coming to sing! He's doing a bunch of shows overseas and stopping here on the way."

I'm sure medical professionals would dispute this claim, but I swear that if I shut my eyes for more than five minutes over the next four weeks, I don't remember it. I was too obsessed with perfecting my act and scheming a way to meet Jolson to bother with something as trivial as snoozing or rest.

Finally, the night of the show arrived. I was scheduled to go on about an hour before Mr. Jolson would take the stage. I was

50

listed on the bill as leading a small jazz combo. We had a drummer, a bass player, a cool dude from the Bronx on saxophone, and a trombonist with an overbite so bad that I never understood how he was able to get both lips into the mouthpiece. I was to conduct and lead the group, but my drum kit was set up on the side and I would join in on a couple numbers.

At least, that's what was printed on the bill.

But I had no intention of simply standing there and conducting the group. No sir, I wasn't going to miss this opportunity. My plan was to turn our thirty-minute set into my own variety show.

Onstage with the combo, instead of just standing there waving my hand, I danced around and twirled my baton. In between songs, I told jokes that broke up the crowd. During one particularly fast tune, I dashed over to my drum set and played a rhythm on the hi-hat cymbal with my left hand while still conducting the band with my right.

I worked myself into such a whirlwind of shtick that the whole performance was over before I knew it.

The crowd roared in appreciation and I felt the sweat running down my back and under my arms as I waved to all the soldiers in the audience. Someone handed me a towel and people patted me on the back as we made our way backstage. The guys all wanted to grab a beer, cool down, and enjoy the rest of the evening. But I wasn't going to budge from my spot in the wings on the side of the stage.

When Al Jolson strolled into the spotlight, I sat on a crate and watched the performance with the same intensity as when I studied *The Jazz Singer* all those years earlier. I observed the way he leaned back and stretched his arms out wide. I noticed how far he raised his eyebrows and how big he smiled to the crowd. Everything was done to exaggerate his movements, so he could connect with the audience, even the soldiers way in back.

51

When Jolson started his encore, I knew I had to make my move. Because of all the military regulations, he wouldn't be allowed to perform for hours and hours like on Broadway. He was only going to get two or three more songs before wrapping up.

I hadn't come this far, worked this hard, and gotten this close to my idol to sit back and not take advantage of the situation.

I hopped off the crate and straightened my tie. I grabbed a tin cup of water someone had left behind and chugged it down, gargling some to clear my throat.

Jolson was singing the very songs I'd loved so much as a child. There was a single spotlight on him, and he dropped to his knees and threw out his arms as if he wanted to hug the whole world.

The crew was crowded in the wings, watching the world's greatest entertainer command the audience. Peeking through, I could see the wide-open stage with my hero on it. In the distance beyond was a cordoned-off section where the military base's leadership sat.

A spare microphone, used by the emcee to introduce Jolson, sat on a stool next to me. It was turned off but still plugged into the house sound system.

I thought about how I had snuck into that movie theater to see Jolson's films, how I taught myself to drive a truck to make money for band camp, how I beat the odds to become drum major in high school. I thought about all I had done for my entertainment dreams.

And I thought about how I might never get another chance like this.

So I broke into a trot toward the back of the building, through the concrete-block maze of rooms, storage closets, and mechanical equipment. I raced up and down the various hallways until I finally discovered Jolson's dressing room. An MP stood outside the door.

The building was rumbling with applause from the show. I knew Jolson's act was over. He would be taking his bows and heading back here any minute.

"Hey, some drunk private is around the corner, with no shirt on, waving a bottle of Jack Daniel's around and cursing like an oil rigger!" I told the military guard. "What is Mr. Jolson going to think of our base when he sees a lamebrain like that?"

The MP ran off to find the fictional drunk and I quietly opened the dressing room door and slipped inside. It was just a simple white cinder-block room, with a green couch on one side, several metal chairs, and a table along the wall. An empty clothes rack stood near the door. It smelled like bleach, and the harsh overhead lights revealed streaks on the floor where it had been recently mopped.

I may have had butterflies prior to the performance that evening, but now, in Jolson's dressing room, I had a belfry full of bats flapping in my stomach.

I tried to think of some excuse, some story I might use to get me out of trouble if anyone from the base came in with Jolson and found me here. I'd be looking at weeks of KP duty *(Fig. 4B)* at the very least. Maybe I could say I got lost. Maybe I could say that I was told to come here. Maybe...

And then the door opened.

Fig. 4B

And Al Jolson walked in.

And he was alone.

Just standing in his presence was like being with a king. I began stuttering, and somehow managed to spit out, "Mr. Jolson, if I could have a few minutes of your time," before he interrupted me.

"Young man, let me tell you something. I saw your act and you were good. Very good!" He sipped from a glass and wiped his face with a towel.

I don't remember being able to focus on anything. My mind was swirling with emotion, nerves, pride, and excitement. It was like looking through a kaleidoscope.

"My father took me to see *The Jazz Singer* when I was a little boy!" I said. "Since then, I've had your pictures on my wall. I've seen all your movies, listened to all your songs." I knew people probably gushed over him all the time with comments just like mine. But I had to try to explain how important he had been in my life.

Jolson lit a cigarette and sat down in one of the chairs. He motioned for me to sit next to him. It was clear that he knew how to calm adoring fans. He asked where I grew up and what I did in the military, and he made small talk about sports. If my father could only see me, sitting in a dressing room, casually chatting about Ohio State football with the great Al Jolson.

"I appreciate you telling me how my work impacted your life," he said. "That's always nice to hear. But I gotta tell you, I saw you onstage and there is something special about you. I don't know what it is, but you've got a way, a showmanship. What do you want to do when you get out of the service?"

"Right now, I'm just hoping I finish up with ten fingers, ten toes, two arms, two legs, and one brain intact."

He laughed and said that was probably a smart goal to set for myself.

"But afterward, what do you want to do with your life?"

"Well, after I'm discharged, I aim to go to college. I did real well in high school, particularly in the sciences. And I like to help people. So I'm going to be a doctor."

Being a soldier was enough of a risk. If I made it out of the war alive, I figured I'd do the safe thing for a change, and open a nice family practice and take it easy.

He raised his eyes to the ceiling, clenched his jaw a bit, and hummed. Finally, he said, "Being a doctor is very respectable, and sure, you'll help people. But I feel like you need to have a bigger reach. As a doctor, you'll touch hundreds, maybe thousands of people. But you should think about reaching even more."

There was a knock on the door and a man wearing a fedora cocked back on his head leaned in to tell Jolson that his car had arrived.

"Good luck to you, son," he said. "Be safe and I wish you all the best out there."

"Thank you so much for your time, Mr. Jolson. I'll remember these moments forever and ever!" And he walked out of the room. I sat back down in the chair and let my mind soak in all the details of what had just happened. Then I dashed back to my bunk and wrote a letter to my parents, recounting every second of meeting the legendary jazz singer.

After that, life returned to normal on the base. The entertainment factory inside my head shut down, so I finally got some sleep and refocused on my training. The next few months passed unremarkably—until I was asked to perform at another event.

And Al Jolson would be headlining the bill again.

I was given a worse slot this time. I would be onstage hours and hours before Jolson. He probably wouldn't even be in the building during my performance. I still pushed myself to practice so I could excel, do even better than last time, and prove myself. But I wasn't

55

as anxious and nervous as before because there wasn't any realistic chance of connecting with Jolson.

I went out and gave it my all, just like before. The crowd laughed at my jokes, rippled with the rhythm of our music, and applauded loudly when we were done. I was more relaxed during this performance, and confident that I had topped myself.

During Jolson's act, I sat in the front row and watched him hold the entire audience in the palm of his hands as he sang all his greatest hits.

After the show, I was standing in the parking lot, chatting with a tuba player and a juggler. The backstage door opened and Al Jolson walked out with a couple men. I felt a surge of excitement, but I considered myself lucky to have gotten advice from him once and didn't want to press things. So I decided not to bother him.

However, he saw me and walked over.

"So you still want to be a doctor?" he asked.

"Mr. Jolson, how in the world do you remember that? I wasn't even going to say hello today because I know you're busy. And you were so gracious to me last time."

"Oh, I remember you all right. You've gotten better since that first show. Your act tonight was something else!"

"You saw it?" I asked.

"Absolutely! While I watched you onstage, I figured out what was puzzling me before. You shouldn't be a doctor. You're going to do what I did. I told everyone, 'You ain't heard nothing yet!' and that's what you gotta do."

"So medicine isn't the right choice for me, Mr. Jolson?"

"Call me Jolie. When you meet me twice, you can call me Jolie, not Mr. Jolson. And here's the thing, I want you to think about this: You go be a doctor all right, but a doctor of laughter! Because, as far as you're concerned, they ain't seen nothing yet!"

An assistant grabbed his arm and said they were running late. A car pulled up and he climbed in the backseat. He rolled down the window and put out his hand to shake mine.

"You've still got to fight this war. So staying healthy is your main concern. But when you get out, if you're wondering what to do with your life, just think about what I said."

The car pulled forward through a gate in a chain-link fence and I watched the taillights disappear into the night. That was the last time I ever saw Al Jolson in person. I stood there in the parking lot, staring into the black night sky, trying to absorb what had happened. I was thrilled he'd remembered me, proud he'd said my performance skills were getting better, but confused by his advice. For as long as I could remember, I loved to entertain. But that passion was always balanced by the more practical idea of helping sick people and providing for my family.

Yet this man had exerted such an amazing influence on my life. I idolized him for so many years and then to meet him . . . it seemed like fate was steering me in a particular direction. As I lay in bed that night and pondered my future, I never would have guessed that the jazz singer's advice would someday push me toward a wig made of yak hair and giant red shoes.

"...when you see me smiling and you hear the audience laughing, watch my feet."

JOHN PHILIP SOUSA AND MY BABY SITTER !!!

A WALK WITH THE MARCH KING

WAS LUCKY ENOUGH TO FINISH MY MILITARY STINT AND RETURN TO CLEVELAND IN 1945 WITH MY LIMBS INTACT AND MY FULL HEALTH, WHICH WAS A FAR BETTER DEAL THAN MANY OF MY FRIENDS. I EVEN HAD A LITTLE GOVERNMENT ASSISTANCE TO HELP FURTHER MY EDUCATION. AND I'D GOTTEN THE OPPORTUNITY TO MEET ANOTHER OF MY HEROES.

Eddie Cantor, the famous actor and radio personality, had performed a show for the troops and, as usual, I'd hammed it up as one of his opening acts. After the gig, he'd congratulated me: "If you ever come to Hollywood—and you should—and need any help, just look me up and I'll see if there's anything I can do for you." I'd made a mental note of Cantor's words, because an offer like that, even if made out of politeness, was no small thing.

Back in Cleveland, I applied to the University of Southern California as my first choice, because it was a good school. It had one of the best marching bands in the country, and it was smack in the middle of the entertainment capital of the world. As a backup, because the chances of making it into USC were slim, I chose Ohio State.

At the dinner table, my parents brought me up to date on the news from the neighborhood and they had something exciting to share. "Your old band director, Ralph Rush, he's at USC now," Dad said.

"He is? Wow, he made it. That's what he'd dreamed about."

It seemed like a good omen. And it was.

Though Mr. Rush didn't even know I'd applied, and probably couldn't have helped me if he had, I was accepted to the University of Southern California.

I left Cleveland during a terrible blizzard. It was horrifically cold and snow just poured from the sky. I got off the train at Union Station in Los Angeles three days later. The sun was shining and I had earmuffs around my head, which I ditched pretty quickly. I thought, "I was born in Toledo, I was raised in Cleveland, and after a long career and exciting life, I'm going to be lowered into the earth in California."

On my first day on campus, I located the music offices and knocked on Mr. Rush's door. His mouth fell open and I thought he was going to faint when he saw me.

"Boy, do I ever feel sorry for the band director now that you're here," he laughed. "You're going to do the same thing to him that you did to me, aren't you?"

"Yes sir, I am. I'm going to do whatever it takes to be the drum major of the University of Southern California Trojan Marching Band!"

"All these years later, I'm a professor here and you're a student. After all we dreamed about and discussed, it's like some kind of magic, isn't it?"

"I'm hoping to pull off some even bigger magic tricks than that," I said.

And I did just that.

The first time I marched in a USC drum major uniform (*Fig. 5A*), under the bluest sky you can imagine, I couldn't believe my dreams had come true: from a child with a broomstick and a whistle listening to Rose Bowl broadcasts on the radio in Cleveland to actually leading

Fig. 5A
**Larry Harmon as
USC drum major**

the Trojans into the grandeur of the Los Angeles Coliseum *(Fig. 5B)*. Dedication, bullheaded determination, hard work, the love of music and entertaining, the inspiration of John Philip Sousa, and years and years of dreaming—it all came together on that football field.

Fig. 5B

Many years later, in 1996, the Rose Bowl halftime show honored Bozo. I donned my red wig and massive shoes, rode a float in the Rose Parade, and then worked with my beloved USC Marching Band on the field.

If you had told me when I was in college fifty years earlier that I would be so honored later in life, I would have complimented you

62

on the joke. Other people, however, have told me it was destiny. And one of them was my parents' friend from Toledo, who used to babysit me when I was an infant.

One day, while I was home on break from college, she told me, "You were such a joy. You were the only baby I've ever seen that laughed more than you cried. I watched you one afternoon while your parents ran some errands. It was a beautiful day and I was on the porch with your baby buggy getting ready for a walk. My neighbor yelled out her window to ask if she could join us."

She went on to explain that her neighbor had a relative visiting. And her visitor wanted to see the neighborhood, so the two ladies and the male guest set out on a stroll, pushing me in my carriage.

"The neighbor's guest, the visitor from out of town—do you know who that was?" she asked.

"No," I replied, curious.

"That was John Philip Sousa! He pushed your carriage while we picked flowers along the walk."

I was floored. The greatest march king in the world pushing my baby buggy.

It was just another one of the strange coincidences that punctuate my life's story like the crescendos in a musical score.

It's a musical score that never ends. It's always there with me. And to this day, that's why, when you see me smiling and you hear the audience laughing, watch my feet. I may be wearing Bozo's massive shoes or maybe just regular footwear if I'm not in costume. But you'll see my feet tapping, keeping the beat, as I enjoy the music of laughter that is the soundtrack of my life.

"I've chased it like that drum."

EDDIE CANTOR AND THE SHADOW MAN IN THE RUNAWAY DRUM

FOR SUCH A GRACEFUL MAN, FAMOUS FOR BEING SO LIGHT ON HIS FEET, HE SURE MADE A LOT OF NOISE AS HE WALKED ACROSS THE EMPTY SOUNDSTAGE. OR MAYBE THAT WAS JUST MY HEART POUNDING.

The massive MGM soundstage was empty and dark when I arrived, as instructed, at 3 P.M. sharp. Only a single spotlight lit a portion of the stage. I couldn't find the utilities box to turn on any additional lights and no one was there to help me. So I crossed the darkened room and set up my pearl-finished Slingerland bass drum, snare, tom, cymbal, and hi-hat in the meager pool of light.

Thirty minutes went by with me patiently sitting at my kit. Suddenly, the front door opened and blinding afternoon sunlight blasted in. A silhouette appeared in the doorway. I could see the outline of a trim, athletic man and I could tell he was wearing a suit. He stepped into the cavernous soundstage and closed the door.

The room dropped back into darkness and his footsteps blasted like dynamite explosions as he walked across the wooden floor.

I had no idea what I had gotten myself into.

It all began when I first arrived in Los Angeles for college, determined not just to be the drum major at the University of Southern California, but also to find any show business work I could in Hollywood. I remembered Eddie Cantor's offer to me when I was in the military, but I didn't know how to take him up on it. Obviously, his phone number wasn't listed. And I couldn't just hope that I would bump into him on the street.

One day, however, I heard he was doing a show at the Palladium. Always willing to try anything to achieve my dream, I took a chance. Around the time the show was supposed to end, I went behind the venue and stood by the backstage door.

Eventually, the door opened and Eddie Cantor walked out.

"Mr. Cantor, you probably don't remember me," I said. "We met when I was in the service—"

"Oh, yeah. The Army. I remember."

Right there and then, Eddie made good on his promise. He offered to help get me an audition for a radio production based on a book series about the fictional exploits and eccentricities of a detective named Nero Wolfe. He gave me a business card, and I called and eventually booked an audition for the following week.

When I got to the studio, the producer asked if I could do three voices for the same price. "Sure, no problem. Not just voices, but I'll learn three new languages and impersonate a woman and a Holstein cow *(Fig. 6A)* if you need it," I told him. He hired me.

Fig. 6A

When it came time for the taping, I got there super early. I wanted to see what all went into the production. In the studio, there was a table with chairs around it and a few lamps on it. And a very handsome, regal-looking man with silver hair was sitting there.

"Are we doing *Nero Wolfe*?" I asked.

"Yes," he replied as he shook my hand. "I'm playing Nero. My name is Francis X. Bushman." Bushman had been a huge star in silent films and played a key role in defining Hollywood because, legend has it, he actually owned the land where the iconic Grauman's Chinese Theater now stands.

Besides taking a chance and hunting down Eddie Cantor, the other factor that led me to that darkened soundstage that fateful day in 1950 was college. The USC marching group is frequently referred to as "Hollywood's Band" because of its many appearances in movies, TV shows, and recordings. The connections I made there introduced me to a number of movie studio producers and executives in the late forties and early fifties. During and after college, I picked up bits of musical work on movies here and there, such as the cavalry entrance in *Annie Get Your Gun* and some war scenes with John Wayne in *Sands of Iwo Jima*. I even had a scene in *The Red Badge of Courage* playing a bugler riding a horse: All that horn blowing and cavalry work in the military had actually paid off.

When I wasn't in the band or on screen, I worked in the background, conducting, training instrumentalists, and helping composers come up with innovative themes. I was willing, as usual, to do whatever it took for as little as people wanted to pay me. This enabled me to advance through the business quickly, because the decision makers knew I was hardworking, motivated, and wouldn't sit around blabbering all day. I was going to come in and get the job done as efficiently as possible. I wasn't going to walk off set when things got difficult or leave for the day before the job was finished.

I was dashing out the door one morning when I received the phone call that would summon me to that darkened studio. A man from MGM called to ask if I was available the following afternoon.

68

I told him I could be, although I would have to rearrange some other obligations.

"I sure would appreciate it, Larry," he said. "We desperately need you. We have a big time musical production that's at a standstill because we just can't get one of the key numbers right. If you could come down and just bounce some ideas around with us, it would be a big help."

"Sure, I can do that. What's the film?"

He cleared his throat and I could hear him adjusting the phone in his hand. "Well, that's just the thing. I can't tell you the name of the production. The executives want this kept under wraps."

"Okay. Who am I working with?"

"I can't tell you that either. Just get here tomorrow afternoon with your gear. You'll get more details then."

That's all I knew as I sat in the soundstage as the mystery man walked toward me. He *had* to be someone important, or else there wouldn't have been so much secrecy. In those days, the biggest stars in the world were still somewhat approachable within the confines of a studio setting. It wasn't like today when celebrities have armies of assistants, managers, bodyguards, makeup artists, and publicists who battle for closed sets and insist on confidentiality agreements. Back then, that shadow could have been anyone walking toward me.

"Hello, Larry, my name is Fred."

He came into the light and smiled. Slightly numb, I found myself shaking hands with the legendary Fred Astaire.

"I'm working on this new picture called *Royal Wedding*. And we sure are stuck on this one dance scene. The guys in the office said you might be able to help."

And so began two long days of working with the most famous dancer on the planet. For the most part, the soundtrack for the movie had already been written. But Astaire was still trying to come

up with a dance routine for a scene during which an ocean liner crossing the Atlantic is caught in a storm *(Fig. 6B)*. In the script, Astaire and his costar, Jane Powell, were supposed to entertain the crowd in the ballroom while the floor pitched steeply from side to side.

Fig. 6B

"Just start playing some rhythms," he told me. "We'll see what works."

This lasted for hours. I would pound out one rhythm, and he'd want to change something; I'd pound out another rhythm, and he'd suggest another change; and so on. We kept evolving and brainstorming through these patterns, with me behind the kit and him dancing in front. Astaire was one of the hardest, most diligent workers I had ever seen. He was famous for his perfectionism, and my hands and arms were aching by early afternoon from all the work.

It wasn't until after sundown that we finally got the rhythm licked. "Thanks for all your effort, Larry," Astaire said. "Let's pick back up first thing in the morning."

We spent the next day refining the counts and the rhythms. During one of our quick breaks, he told me that Judy Garland was supposed to have been the lead in *Royal Wedding* but health problems prevented her from performing. At the time, I thought

70

this was the pinnacle of my career: getting inside information on Hollywood from Fred Astaire and observing him run through his world-famous dance moves just feet away from me.

When we wrapped up that second day, Astaire clapped me on the back and told me, "You've made a tremendous difference. I really appreciate your help."

I was proud that such an important Hollywood star respected my input so much.

"In fact," he continued, "I'm going to talk to the director. I want you to be in this picture!"

And so that's how I got some screen time in a Fred Astaire movie. In *Royal Wedding*, during the scene when the ship is tossed in the storm, spilling fruit onto the floor while Astaire and Powell dance, you'll see me sitting in the band behind a small drum set. As the dancers slide away from the orchestra, down toward stage right, my bass drum rolls across the parquet like a runaway bicycle tire. And I go chasing after it, trying to corral my wayward instrument.

In a way, those few seconds on-screen represent my whole life. I've worked hard for everything, be it great or small. And I've never rested or grown comfortable with my success. Instead, I've chased it like that drum. Because I know that, like a spinning record or a rolling film reel, the entertainment world doesn't stop. People's need for laughter and enjoyment is unrelenting and endless. So I've never let myself give up the chase, because if I do, I know that my dream will roll away from me.

71

"It's a fact. It just hasn't become a fact yet."

COMMANDER
COMET
★ ★ ★ ★ ★ ★ ★ ★ ★
GORT
◌◌◌◌◌◌ THE ROBO
AND CHUCK
YEAGER !

Larry Harmon as Commander Comet

SPACE
IS THE PLACE

AS CELESTIAL BODIES MOVE THROUGH THE SOLAR SYSTEM, THERE'S A PATTERN OF APPEARING, DISAPPEARING, AND REAPPEARING. WE SEE THE SUN, OUR SKY GOES DARK, AND THEN THE SUN RISES AGAIN IN THE MORNING. HALLEY'S COMET MAKES AN APPEARANCE, MOVES ON, AND THEN BLAZES THROUGH OUR HEAVENS SEVENTY-FIVE YEARS LATER.

Those objects don't cease to exist when we can't see them. They're still out there and they reappear in our lives like a recurring motif in an opera.

Certain ideas, dreams, and fascinations have always been a part of my life. They pop up to occupy my focus from time to time, and then I move on to pursue another dream. But looking back over my experiences, I realize now which ideas appeared, dissipated, and reappeared throughout the decades. Like an astronomer charting the appearances of Halley's Comet *(Fig. 7A)*, I can look back and see the consistent threads of my life.

Besides music, one of the other major threads was the idea of space—of this vast galaxy and the infinite black above us. It occupied my imagination as a young child, served as the basis of one

Fig. 7A

of my first jobs in Hollywood, and later urged me to train with astronauts and experience zero gravity.

When I was five years old, my parents purchased a refrigerator from the Sears Roebuck catalog. After the appliance was installed, my mom beamed at the gleaming addition to her kitchen. My father returned to the Cleveland Indians game on the radio. And I investigated the empty shipping box in the backyard.

That box became my pirate ship, my tank, my stagecoach, my castle, my tunnel, my mountainside. I would lug the box upstairs in our house, climb in, and slide down the stairs like a runaway train. Anything a little boy could envision, that box could accommodate. But its most frequent incarnation was as a flying vessel. Sometimes a plane, like the one in which I imagined Lindbergh crossed the Atlantic. Other times, the box became a flying saucer (*Fig. 7B*), capable of propelling me into the heavens like the brave souls in Jules Verne's science-fiction stories. I felt the urge to fly, to travel at high speeds, to leave a mark in the sky that people would see.

Over the years, the box started to wear down. My friends moved on to other games. But I still spent hours with it in the backyard, with imaginary robots, as I frantically worked the controls, struggling to hold the rudder straight while buffeted by the force of winds and weather as I yearned to break free of gravity, imagining myself in space.

Fig. 7B

Just as I reached the age where it no longer seemed right to play in a box in the backyard, it fell apart, finally succumbing to weather and abuse, the few remaining nails rusted and stripped and useless. My father threw the remnants in the garbage.

But the fascination with space and air travel never left me. When the Army sent me to Kansas to train with the cavalry, during breaks on the base, I would listen to radio reports of the Navy airplanes in the South Pacific. And while on leave, I would go to the picture show and see newsreels of the Allied Forces' dogfights with Hitler's Luftwaffe air force. I was fascinated by what those planes could do.

"You need to stop pondering them planes and get yer mind on cleaning that rifle," Dampier said. He was a bespectacled country boy with a thick Southern accent from Harlan County, Kentucky, who slept in the bunk next to mine in the barracks. We were sitting, enjoying the sun on a warm day, leaning against a cinder block wall of the motor pool building. Parts of our regulation issue rifles lay scattered around us. Dampier smoked a cigarette and focused on cleaning his action. But I stared into the clear blue sky.

"Those P-51 Mustangs can fly almost four hundred miles an hour!" I exclaimed. "Just think what they'll be able to do in a few years. In ten years even! They'll go for five hundred, six hundred, seven hundred miles an hour or more."

"Ain't no way that's going to happen," Dampier said. "The machine can't handle that. And yer body damned sure can't handle that."

"It'll happen," I said. "Mark my words. Someday, you're going to pick up the newspaper and see that a plane has gone faster than you ever thought possible. And then a spaceship is going to leave the sky entirely."

Dampier snorted and hunkered down on the bolt of his rifle. I left the pieces of my weapon scattered as I watched the bright clouds slowly make their way across the sky.

As I struggled after graduating college to make it in Hollywood, my dreams of space couldn't have seemed any more distant. Until one day I found myself at an audition on a back lot of the still relatively new National Broadcasting Company (NBC) television studios. It was for a new children's program they wanted to make about a space pilot from Venus named Commander Comet, who serves as a sort of guardian angel and mentor to the people of planet Earth.

Before I stepped through the red curtains for my screen test, I thought about that refrigerator box in Cleveland, Ohio. I remembered the exhilaration of racing it down the stairs. I felt the way my arms shook when I imagined the force of re-entry from my space voyages. I heard the roar of the engine, I felt the cold of the infinite void, and I sensed the fear of the space aliens. I harnessed all those old memories, walked into the spotlight, blew the producers away, and won the audition.

They wanted me to be Commander Comet, one of the first spacemen ever to appear on television. At the time, it seemed like

a long ways away from being a kid in a refrigerator box, but perhaps it wasn't. It was still make-believe, just in a bigger box.

Though I had already been in movies, done some radio, and worked on other television shows—even holding a recurring spot in the cast of a puppet show called *The Adventures of Patches*—this was my first regular gig as the main star. I felt an incredible amount of pressure. But I was determined to do an excellent job because Commander Comet's turbo-thrusters could propel my career forward.

Our budget was almost nonexistent. Everything was so elementary and basic back in those days. No one even knew if television would last. You had some shows that were successful, such as Milton Berle's *Texaco Star Theater*. But most of the industry was like the Wild West, with no rules and no strategies for success. It was bare bones and experimental, and we flew by the seat of our pants on that show. We produced all kinds of special effects for mere pennies. We may not have had the computer-generated graphics and images they have today, but we more than made up for it with creativity and humor.

I was the live-action star of the show and we had ten or twelve hand puppets that were my co-stars. I dressed up in this beautiful shiny costume as the space commander. I wore tall, black leather boots and a cape that rose off my shoulders like wings. Long, flared, super-hero style gloves went up to my elbows to complete the outfit. And I had a flying saucer, which I helped the stage designers build.

Beyond those contributions from the stagehands, creating this fictional galaxy for the viewers rested entirely on my space-suited shoulders. I had to do my own character of Commander Comet, plus control and provide voices for at least six of the hand puppets. I even had to read the commercials. And I had to make it all interesting and humorous to both children and adults, because we were on from six to seven in the evening, five days a week.

After a few episodes, I felt the show needed another character to bring it to life. The stage was a little cold and empty. So I thought back to my cardboard box fantasies when my friends had abandoned me, and I purchased Gort, the nine-foot-tall robot that had been used in the 1951 film *The Day the Earth Stood Still*. I made some changes to his appearance, rechristened him Rotar *(Fig. 7C)*, and set him up near my spaceship. He traveled all over the galaxy with me.

Fig. 7C
**Larry Harmon as
Commander Comet
with Rotar**

Though *Commander Comet* wasn't a talk show per se, I invited important and entertaining folks to sit with me at the controls as special guests. More often than not, I booked space experts, like scientists who worked on rockets for the government *(Fig. 7D)*. And we forecasted developments in space travel.

As a result, the show became somewhat controversial. We got grief from a few parents. They argued that we were filling children's heads with sheer fantasy and lies.

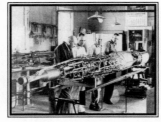

Fig. 7D

"These things will never happen!" one concerned mother wrote in to the station director. "Commander Comet tells our kids that we'll fly commercial airplanes at five hundred miles an hour and then we have to break the truth to our children. We have to tell our little boys and girls they won't visit space and they won't fly all over the globe."

The station manager chomped on his cigar and stormed into my dressing room.

"But those things are true," I told him.

"We have planes that can go five hundred miles an hour?" he pressed. "The propellers would tear off! How can you say that's true?"

I looked him square in the eye. "It's a fact," I said. "It just hasn't become a fact *yet.*"

One of my guests was a man who had grown up poor in West Virginia. He was a decorated fighter pilot in World War II. And he had flown in an airplane faster than the speed of sound.

Major Chuck Yeager *(Fig. 7E)* sat at the controls of my flying saucer on the *Commander Comet* show as I interviewed him about that experience. He talked about going more than five hundred miles per hour, more than six hundred, more than seven hundred.

"Do you think it's possible that we will have commercial airplanes capable of traveling five hundred miles per hour one day?" I asked the famous pilot.

"Absolutely," he responded.

80

Off camera, we stood outside the stage door to catch a nice breeze. Yeager told me he actually flew faster than the reported Mach 1.06, but the government had declared his true top speed classified.

Fig. 7E

For another show, I demonstrated how we could reach the moon. I took footage of all kinds of rockets and machinery, and edited it all together.

"When our ship gets to the moon, how are we going to land?" I asked my viewers. "With retro-rockets! They will ensure a safe landing on the rocky, inhospitable surface of the moon. An astronaut will step out in a space suit, like the one I wear, and conduct research and experiments. Then a portion of the lunar landing module will fire off and return him safely to Earth!"

Boy, did the switchboard light up. Afterward, the station manager stomped into my dressing room, once again telling me I was crazy.

After the *Commander Comet* show ended, I dismantled my flying saucer, put Rotar in storage, and moved on to other endeavors. Space receded into the background of my consciousness once again—at least until one day decades later, when I contacted NASA and asked them to launch me into space as Bozo the Clown.

"...so he can live forever."

KNEW I WANTED TO LEAVE MY MARK ON THIS EARTH. ULTIMATELY, I DECIDED THAT WAS BEST ACHIEVED BY WEARING SIZE 83 TRIPLE-A RED SHOES, BECAUSE PEOPLE WOULD NEVER BE ABLE TO FORGET THE MARKS OF THOSE FOOTPRINTS. BUT IT TOOK A WHILE TO REACH THAT CONCLUSION.

Because this was the early days of television, *Commander Comet* and my small acting and music jobs weren't enough to survive. So I took any paying gig I could get to fill my spare time. If you wanted to catch me, you had to be either quick or lucky, because I was on the run more than an Olympic sprinter. I did everything from working as a private investigator to decorating the homes of Hollywood celebrities like Clark Gable to overseeing a wholesale brokerage company. My calendar had so many notes, scribbles, and squiggles, it looked like ancient papyrus filled with hieroglyphics.

My father had always dreamed of having a jewelry business, so after I earned a bit of money from these jobs, I found an empty storefront and bought a jeweler's loupe. Mom and Dad moved out from Cleveland and, together, we threw open the doors for business.

In the morning, I would get up early, run out to Huntington Park where the store was located, and trim the windows. I had to put out all the rings, watches, bracelets, and necklaces that had been stored in the safe overnight. Then Dad and I went over the

day's schedule, deciding who was manning the counter, and who would meet with visiting salesmen from New York. If I was filming a picture that afternoon, I would dash across town to the set, work there for a couple hours, and then head to NBC to spend four hours doing pre-production before filming *Commander Comet*.

Most nights I spent gigging with a little jazz outfit I had at the time, so I would race from the studio to the club with my drum kit, which I always kept in the trunk of my car because I didn't have time to run home to retrieve my gear. Around midnight, we'd finish the set, tear down our equipment, and I would finally open the door to my apartment on the Miracle Mile. I would sit at the kitchen table and handle accounting chores or write comedic routines until one-thirty or two. Then it was finally time to get a little shut-eye before getting up at five in the morning to start the whole thing over again.

A few nights, I never even went to sleep because I was moon-lighting as a private investigator. So I'd have to stay out until dawn trying to find a missing person or checking up on a suspicious spouse, which was always a booming business in Hollywood.

Despite having more irons in the fire than a blacksmith at the Kentucky Derby, I still thought about applying to medical school. I knew it made sense to have a stable, respectable, well-paying job.

So I was running in twenty different directions and didn't know what to do with my life. It was a weird feeling. I wasn't putting myself through all this in pursuit of money but in pursuit of an insatiable desire to try more, do more, achieve more—to live more. On the surface, no one could say I lacked ambition, dedication, and the willingness to do whatever it takes to be a success. But deep down inside, on those rare evenings when I had a few extra moments to sit in my apartment and look out at the expanse of Los Angeles from my window, I felt like I lacked focus.

I had all this energy and all this creativity. But how to harness it? What, I wondered, was the one thing I could zero in on to achieve my dreams?

One afternoon in 1952, we were taking a break on the set of *Commander Comet* and one of the stagehands said that Capitol Records was holding auditions to find an actor to portray Bozo the Capitol Clown. They had created the character for a series of highly successful children's records in the late forties, but now they'd decided to branch the clown out into film and television. At the time, I leapt at every audition I could get. I would have tried out for the role of Silver, the Lone Ranger's horse, if they had let me. Even if I didn't book the gig, just doing any audition was valuable experience.

So I found myself baking on concrete one blindingly hot day as a bunch of other actors and I stood around waiting to try out for the role of Bozo the Capitol Clown. The record executives at Capitol called my name and I stepped into a cool room and waited for my eyes to adjust to the darkness. They asked me a few questions about my work history, particularly *Commander Comet*, and then they described the Bozo character and asked me to demonstrate how I would portray him.

Of course I had done my homework and listened to all the records, so I stepped right up and put on a show. The great American sportswriter Red Smith once remarked, "There's nothing to writing. All you do is sit down at the typewriter and open a vein." For me, at the time, acting was easy: just step onstage and rip out a funny bone.

I was so excited and so determined to have a good audition that I got into this zone and it all just went by. Suddenly, they told me they had seen enough.

I was worried I'd gone too far, that they didn't think I was right for the role. But when I looked up, they were smiling. I got the job. I would be Bozo the Capitol Clown!

When I tried on the costume for the first Bozo television pilot, which was titled *Pinky Talks Back,* it just felt natural. Those shoes might have been big, but they seemed comfy and welcoming to me, like a favorite pair of sneakers. As soon as I walked onto the soundstage, every child within eyesight just laughed and clapped his or her hands. Commander Comet didn't generate the type of love that Bozo did. Something about the combination of that clown gear and my personality just seemed to click. I could see it in the children's eyes.

In the early years, I wasn't the only performer in the Bozo costume. They also hired a few other actors to portray the character here and there. A couple years went by and I continued working my day jobs, portraying Bozo, and picking up any other work I could find. But I still had that feeling of scatteredness, as if I were being pulled in too many directions.

Around two in the morning one night, I returned home after racing all over Hollywood from job to job. I had a two-door powder-blue Cadillac convertible at the time, and the seats were piled high with costumes, scripts, notes, and musical equipment. An upright bass stood in the back, propped up like a statue. I often complained about the fact that between the drums and the bass, I had chosen two of the most cumbersome instruments in existence.

My band had weathered a tough gig that evening. Our sax player had broken up with his girlfriend and couldn't focus, so he was all over the place musically. The rest of the group did its best to remain professional and keep it together onstage, but the show was bad. So my mind was churning when I got home that night.

Now, I have to admit something unusual about myself. Maybe it's even a little weird, but it's just me. I never get depressed; I don't get pessimistic about things. It's not that I'm naïve or unrealistic

87

about the challenges in life. Rather, it's just that I'm convinced there is always a way. If it seems like something isn't working out, I don't mope around about it. I just rack my brain to devise a strategy to *make* it work.

So, even though I should have been physically exhausted, I felt energized that night, staring at the lights of Hollywood and Los Angeles, determined to find the right script for my life.

Al Jolson told me to forgo a career in medicine and instead be a doctor of laughter. Though I was keeping busy in films here and there, to really make it in the movie business seemed darn near impossible. You had all these huge comedy stars like Dean Martin and Jerry Lewis. Nobody was going to be able to jump into that world. It was too established, too cliquish.

But television—now that might be a possible place to get a foothold. Although the technology had first been introduced in the late twenties and early thirties, television was still a relatively new phenomenon by the mid-fifties.

I walked into my kitchen to get a glass of water and saw my clown costume hanging on a hook by the door, so I could grab it as I dashed out in the mornings if I had to perform that day.

Bozo.

When I was a child, staring at Al Jolson smear shoe polish or burnt cork or whatever it was over his face to transform his character, I never would have dreamed that putting gunk on my own face would seem so comfortable to me. But it did. Every time I put on the clown makeup, it just seemed right.

I got my water and set it down on the counter, forgetting actually to take a sip.

Now, Bozo might be something I could work with. But I didn't want to be just a clown. The world was full of clowns and, sure, they made people happy. I enjoyed seeing circus clowns piling out

of tiny cars as much as the next guy, but I wanted to cross over, to do something a bit different. I wanted to be an entertainer.

I sat on the couch and grabbed a notebook. Buddy Rich's tune "Little Train" spun on my record player as I jotted down notes without thinking, just random things that popped into my head:

- *Makeup, Al Jolson = brand new identity.*
- *Show no plain skin at all, nothing "human" so he can live forever.*
- *Dancing, singing, entertaining children.*
- *An actor, a musician, a comedian, they can all die and fade away—what lasts forever? Characters do. Lone Ranger, Green Hornet, Superman. They'll survive for decades.*
- *A symbol.*
- *Something apolitical, non-religious, non-ethnic, non-economic class. Something approachable and welcoming to all people. Belonging to the world.*
- *Involve everyone.*

I kept writing and brainstorming until I heard the garbage man banging trashcans on the street outside my apartment. The sun had come up and a light haze was starting to burn off as the morning air warmed. By that point, I had devised my plan: Bozo would be my vehicle for spreading entertainment and laughter across the globe. I would transform Bozo the Capitol Clown into Bozo the World's Most Famous Clown.

But for this to happen, he'd have to transcend the traditional boundaries of clowndom and become a television personality and an all-around entertainer. He would have to work in any genre and medium of existing entertainment: television, movies, cartoons, recorded music, books, live shows. I opened my window and smelled coffee from the neighbor's apartment. I drew in a deep breath and said quietly, to no one in particular, yet also to the entire world, "You ain't seen *nothing* yet."

89

As soon as 9 A.M. rolled around, I was on the phone to Capi-tol Records, setting up an appointment so I could inquire about purchasing the character that would become a part of me.

I soon found myself sitting at a large walnut table in a confer-ence room with a whole row of record-company big wigs staring me down.

"You guys are taking off with Frank Sinatra and Judy Garland and all these great singers and musicians," I began. "Bozo has been good for you, no doubt. But from what I can see, this isn't a major concern for you anymore."

They agreed that the Bozo records had helped propel the com-pany, but that their focus today was on this new batch of musicians.

The suits went for my offer to purchase the character in in-stallments over time, and a short while later we signed the contract. Suddenly, I owned all the rights to Bozo the Capitol Clown—with the exception of the masters for the records that had already been released, which was fine with me because I knew this was a new era anyway. Television would be the medium and Bozo the vehicle to achieve my dreams. I ran out of the office into the afternoon sunshine and screamed with joy as I jumped into my convertible and roared down Hollywood Boulevard.

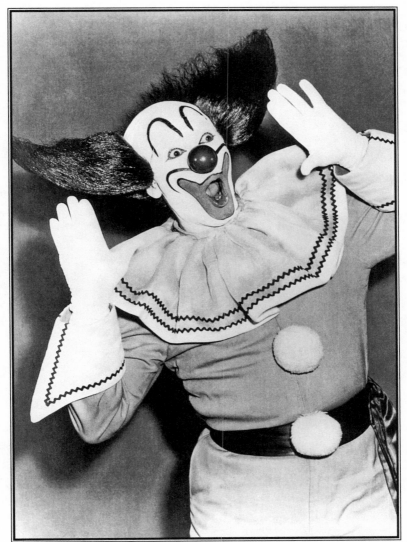

Larry Harmon as Bozo the Clown

"I'm probably the only person in the world who had to buy his hairspray at a hardware store."

BOZO AND ZIGGY IN

HOW A YAK SAVED A CLOWN

THE CELEBRATION OF MY VICTORY AT CAPITOL RECORDS DIDN'T LAST LONG. I HAD TO RETHINK AND RETOOL THE CHARACTER SO IT COULD REACH AN ENTIRE EARTH'S WORTH OF PEOPLE.

First, I changed the clown's mannerisms. I wanted him to have more energy, more pizzazz—and to be smart. He shouldn't be slow-witted, clumsy, or gullible. He needed to have the wisdom of an adult but retain the wonder of a child. Then I worked on the voice and the laugh, a *yuh-yuh-yuh-yuh* that gears up in volume and energy with each syllable, like a pressure gauge rising with hilarity at each chuckle.

Then I focused on a characteristic that would become a symbol around the world: the hair.

Originally, the character had a wig like a mop. Limp, curly red hair hung on the sides and back of his head. I wanted something more forceful, more dramatic—something that would make the character look as if he could just fly off the stage. I envisioned hair that flared out, giving an impression of wings.

I sought out the best hairstylists and wigmakers in Hollywood and ended up with a gentleman who went by the nickname Ziggy. He had worked with all the major studios and was famous for creating wigs that would fool the camera into making a beautiful brunette starlet look like she really was a blonde—or fool that same starlet into thinking the producer really had a full head of hair (*Fig. 9A*).

Fig. 9A

We must have gone through a dozen different prototypes for the wig. It had to be strong enough to support itself, with nothing suspending it from above or supporting it from below, like a cantilever in architectural terms. It had to stand up to lots of abuse and wear and tear from travel and performing. But I also wanted a gracefulness to the curve.

We tried yarn, string, fake hair, horsehair, and half a dozen other kinds of animal hair. But nothing worked. My head couldn't take many more wig auditions (*Fig. 9B*); I felt like my skull was shrinking from the tightness of some of our prototypes. Finally, Ziggy ordered a shipment of yak hair (*Fig. 9C*), dyed it just the right shade of red, coated it with Krylon, and, surprisingly, it had just

the right strength, support, and durability. I'm probably the only person in the world who had to buy his hairspray at a hardware store.

Fig. 9B

Fig. 9C

With that ordeal over, I began working on the costume. I added big white puffy balls going down the chest where buttons

would be on a shirt. The gloves became white gauntlets, with Bozo emblazoned in red stitching. I tossed in a red sash to add a bit of drum major flair and to break up the costume. I had a seamstress insert a bit of structure to the collar so it stood up and out more, instead of laying flat around my neck. And after a couple hours spent making a tremendous mess in my bathroom sink, I made some subtle adjustments to the makeup.

Now that the character was finished, I turned my attention to the television show. It was tough getting a show on the major broadcast networks; it could take years and millions of dollars. And syndication was just beginning, so that wasn't a feasible option yet.

So I came up with something better than syndication: I would start Bozo locally, and then franchise the show like a restaurant chain or a play after it leaves Broadway. This way, each local station could have its own Bozo show on its own set with its own actor portraying the character. Not only would Bozo be able to touch more lives directly because local kids would be able to attend and to participate in games and win prizes, but children would relate to the show better because the character would be able to adapt to the regional differences in humor and culture. In addition, Bozo would appeal to local advertisers because they would be purchasing ad time on a show tailored to customers who lived in their area.

To launch the show, I went to KTLA in Los Angeles. When they bought it, I couldn't believe my luck. My plan was actually working. What gave the whole thing an extra jolt of excitement was that KTLA had recently moved into the old Warner Bros. studio on Sunset and Van Ness. And that, my friends, is where Al Jolson filmed *The Jazz Singer* in 1927!

Now, on the show, it couldn't just be Bozo onstage. He was a hip, cool, happening cat, so undoubtedly he would be surrounded

97

by friends. I created characters like Professor Tweedy Foofer, Grandma Nelly, and others, sketching out their makeup, costumes, and personalities for the various actors who would one day play them around the world. I even decided to hire an actor to portray Bozo in Los Angeles, so I could concentrate on things behind the scenes.

I sketched this all out excitedly in my notebook. I had Bozo, his kooky friends, a heap of kids, and some games. But something was missing. I was dealing with the attention spans of children, and a live show might eventually get boring to them. I needed another element, something as different as possible to balance out each episode. As soon as I began thinking about what kids enjoyed, I realized that the show needed cartoons. And Bozo, who was so brightly colored and larger than life to begin with, would translate perfectly to that medium. He could travel around the world, have all kinds of adventures—even do crazy things like sleepwalk off skyscrapers and not get hurt, which furthered this idea of the character being able to live forever, long after I'm gone.

In addition, I could offer the cartoons as part of the package sold to all the local Bozo shows around the country. They'd be able to play the shorts and keep the kids entertained while the performers regrouped. So I borrowed some money and built a small animation studio to create these short cartoons.

We went live on a Monday afternoon. We had called local schools, Boy Scouts and Girl Scouts groups, and churches asking them to gather up about seventy-five kids to be on set to interact with Bozo. It was as if I were hooked directly into a massive electrical substation. I was so excited, it felt like every hair on my body stood straight out.

The red light went on, the kids started clapping, and the actor portraying Bozo pranced out and faced the camera.

"Howdy! This is your old pal Bozo and we've got the most rootin' tootinest, ding-dong dandy show in the whole ding-dong dandy world. Yuh-yuh-yuh-yuh!"

The children went nuts. When I noticed that even the cameramen were smiling, I thought, "We're onto something here!"

At the end of the show, Bozo looked directly into the camera and said, "Well, until I see you tomorrow, remember what your old pal Bozo always says: It's nice to be important, but it's more important to be nice." He leaned back, just as we had practiced, and threw his arms out in a wide gesture and took a deep breath. "So, till I see you tomorrow, juuuuust keep laughing!"

After the show, when all the crew had gone home, I went back out to the stage and just stood there. I crossed my arms and smiled as I looked at the cameras, lights, and empty seats. The afternoon had been a piece of magic, just beyond my wildest dreams.

But this was merely one show in one city. If I really wanted Bozo to live up to the label of the world's most famous clown, I would need some reinforcements *(Fig. 9D)*.

Fig. 9D

"The immutable and sacred vow you take when you put on the red wig . . ."

BOZO
AND THE
WEATHERMAN

IN CLONING A
CLOWN

I N 1959, I STARTED TRAVELING AROUND THE COUNTRY LICENSING TELEVISION SHOWS WITH **BOZO**, THE WORLD'S MOST FAMOUS CLOWN, TO LOCAL CHANNELS. IF THERE WAS A TELEVISION STATION WITH A TRANSMITTER TOWER, **I WENT THERE,** WHETHER IT WAS A **THRIVING METROPOLIS OR A BACKWATER GHOST TOWN.**

Over the years, my staff and I trained 203 men to wear the Bozo costume in communities all over the globe. Each of them went through a Bozo boot camp so they could learn the rigors—and joys—of portraying the world's most famous clown. I trained a priest in Australia, a boxer in San Diego, and a couple doctors to portray the character. One interesting side effect of my setting up the Bozo organization in this way is that anywhere in the world, in every city that has Bozo, those citizens think he's the only one. To this day, they will fight you on it. They don't realize the huge amount of people who have worn that famous wig.

But I'll never forget one of them, in particular, who impressed me with his dedication.

Washington, DC (*Fig. 10A*), was one of my major target markets. If Bozo the Clown was to become a vital part of Americana, how could he not be on television in our nation's capital? That district would be a keystone of the entire Bozo empire, so the stakes were higher than a circus tent when I flew into Washington National Airport.

Fig. 10A

I took a taxi directly to the NBC affiliate, WRC-TV. I knew if I could just get a moment with the station manager, he'd be hooked.

A secretary led me into an office and told me to wait. I sat there going over the pitch in my head until the station manager walked in. He was slender, with a head full of gray hair and a cigarette in his mouth. He didn't wear a suit coat and his sleeves were rolled up. He had a red, white, and blue tie, which I took to be a positive sign.

"What kind of show is this again?" he asked.

"It's *The Bozo Show*! It's the ding-dong dandiest show in the whole ding-dong dandy world!" I proclaimed. I then explained the show and how it performed in other markets. I did a few bits and added some jokes and one-liners. If you want a boring business presentation, go to a bank or something and ask for graphs, charts, and complex financial equations. But if you want to see a pitch that will have you rolling on the floor, come to me. I'll give you jokes and songs and dance steps. I had most business big shots laughing so much I called my shtick "pitches in stitches."

"Mr. Harmon, I don't know what you're selling me," the station manager said afterward. "But I'm buying it! When can you start? The people here in DC are going to love you."

103

"Oh, I'm based in Hollywood," I replied. "I'm overseeing a show there."

"Well, then how in the heck are you going to be Bozo the Clown here in DC?"

Today, with the term Bozo solidly a part of our language and pop culture, commentators and other pundits might argue that there were a lot of clown candidates in Washington. George Bush and Bill Clinton lobbed the term Bozo back and forth during their campaign in the nineties. Even Bob Dole eventually got into the act, saying, "Bozo's on his way out," at the end of Clinton's term. So an easy joke would have been to say I'd just trot down to Capitol Hill and find any number of bozos. But that time would come later.

At that moment in 1959, the manager didn't think I could cast the role because he had no idea that in his town or any town, I alone could clone a clown.

"I'll train a local," I said.

"But, Mr. Harmon, this is the National Broadcasting Company in Washington, DC," the manager said. "Our staff doesn't do comedy. All these guys are forty or fifty years old. Half of them have heart problems or other health issues. They can't put on such an energetic show!" His brow was furrowed and I could see he was quickly making up his mind. He might have been buying a few minutes earlier, but now he seemed to want a refund.

I hadn't been home in weeks, my clothes were rumpled, and my back hurt from all the traveling around to sell the show. As he kept telling me no, it had to be me as Bozo or no way, it seemed we had reached a stalemate.

I was confident, but I have to admit it looked bleak. My chance for Bozo to reach the children of Washington, DC, was slowly fizzling out, like the air leaking out of a balloon.

Just then, a tall, solidly built man walked by the station manager's door. I got a brainstorm and the hairs on my arms and the back of my neck stood up. I asked who the man was.

"That's an announcer we have here at the station," the manager answered. "He does spot announcing for us. He's been interested in broadcasting since he was eight."

We called the announcer into the office and the manager introduced us.

"Mr. Harmon, this is Willard Scott. Willard, say hello to Mr. Harmon."

I just looked at his face and thought, "Wow." He smiled and it electrified the room. And, boy, he was big! I looked up at him and said, "Willard, take me to your ladder. I'll meet your leader later."

He enjoyed the joke and I thought, that's *the* laugh! That's the chuckle, the guffaw, the giggle, the chortle, and the *yuk-yuk*. That was it! With every man I selected to portray Bozo, I didn't care that much about résumés. I just wanted to know if he had the spark of personality necessary to portray the character.

Since I had begun this journey with Bozo, I had poured my heart and soul, my laughter, my sense of humor, my sense of caring, a lot of sweat, and a whole lot of my bank account into this character. He wasn't some corporate branding idea based on focus groups and what bean counters thought would make money. He was *me*.

And the most important thing about me that I needed my actors to possess was the ability to relate. Could these men relate to children and their parents? And could they do it while dancing and entertaining adorned in red, white, and blue with a wig that seemed ready to take flight at any moment?

"Give me two nights," I told the station manager. "Let me work with Willard, and if I bring him back here and he can say, 'Howdy!

This is your old pal Bozo!' and make you burst out laughing just like I did earlier, will you put the show on?"

"I'll make you a deal," he replied skeptically. "If you can do that, if you can make it happen, then by God, *The Bozo Show* starring Willard Scott goes on the air in Washington, DC." He stubbed his cigarette out in the ashtray. "But to be frank, Mr. Harmon, I don't think you're going to win this bet. No way, no how."

Though he later became nationally beloved as the weatherman on *The Today Show*, back then, Willard had much less experience. But he had been on a kids' show called *Barn Party* where he portrayed Farmer Willard. To flesh out the cast with some barnyard critters, they'd added a group of rascally animals called the Muppets. In addition, Willard did peanut butter commercials with one of the animals, a frog named Kermit who went on to achieve quite a bit of fame. So not only did he have the spark, but he had the experience working in children's entertainment. I was hopeful.

After he got off work at the station that day, Willard met me at my hotel. I knew as soon as I studied his face that he was going to be a great Bozo.

"You've got muscles in your face you haven't used yet," I told him.

"But what should I be doing?" Willard asked.

"You have to exaggerate the smile and the laughter. You have a great smile naturally. And you have a great personality. That's going to carry you a long way. But in makeup as Bozo, you have to go further."

See, most people don't use all their facial attributes. They don't know how to work their mouth and their laugh lines. They don't know what to do with their eyes and their movement, or what to do with their cheeks.

"Once you put on that makeup, you can throw everything you've learned about acting out the window. You need to exagger-

ate your features in order to really project. And you can't rely on the makeup to carry the character either. You, the man behind the makeup, are the person who relates to the audience."

"Well, what do you mean?" he asked.

"See, if you're sitting at the dinner table with someone, telling a funny story about putting gas in your car, you might raise your eyebrows like this, right?" I raised my eyebrows just a bit, as we do in everyday conversation. "But as Bozo, you have to go further. If you say howdy to people and really raise your eyebrows, then you get their attention right away."

He tried a couple times, but it wasn't enough. I showed him how once again, and he raised his eyebrows higher, to the extent where dinner companions might think he's crazy.

"That's *still* not enough," I told him. "It has to go further. Raise your eyebrows high enough that they feel like they're going to rip off your face and take flight."

And then he got it.

I showed him how to exaggerate his speech, elongate his smile, and open his mouth more when he spoke. Nobody walks around talking like that, but in costume, it conveys. It communicates. Why wowie kazowie, it *relates*.

We then went through a number of exercises on speech cadence, because it's imperative that Bozo sounds right. His voice should be warm and inviting. You have to use your diaphragm. He should have the voice of an adult but the energy and wonder of a child. And above all else, he should speak in an exciting manner.

Pretend you just guzzled a gallon of strong coffee and ate six pounds of gumdrops until the caffeine and sugar flood through your veins like a rushing river until you're bouncing off the walls with excitement and energy *(Fig. 10B)*, I told Willard. Use strong verbs, action words, and language that conveys excitement, almost

as if you'd learned to speak by reading comic books with "Pow!" and "Blam!" exploding off the page. Finally, put on the biggest smile physically possible and imagine your eyes are spotlights bright enough to illuminate an airport runway. If you follow that recipe, then you'll sound like Bozo.

Fig. 10B

I showed him the Bozo dance moves and the way of walking. You have to be very flexible and have strong calves to perform in size 83-AAA shoes. Simply walking in them is surprisingly comfortable, I explained, but dancing is a challenge because you're swirling around with what feels like skis on your feet. And stairways are always a challenge.

"You put all that together with the personality of Bozo and you're going to have something that everybody is going to love,"

I told him. "I think you're going to be one of our very, very, very best."

It's not easy though, I warned him. You can never reveal your true self. You have to wake up as Bozo and go to bed as Bozo. When you're in costume or making an appearance, you can't take a smoke break or even remove the gloves to cool off. That would ruin the magic of the character. Children don't see him as a man dressed up like Bozo. They see him as this person who just happens to be all white and red with funny hair. They think he goes home to a family of Bozos who are just like him.

Willard was an undeniably good man, and I was confident we wouldn't have any problems with what I taught him next: the cardinal rule of Bozo. Number one of the Bozo Commandments, the immutable law and sacred vow you take when you put on the red wig, is that you never talk down to a kid. You treat him just like he's a person. Don't think of him as a child or an incomplete adult or a mature-person-in-training; he's just himself. If a six-year-old boy genius from Topeka mentions heart transplants, then great. You talk about anti-rejection medications and the heterotopic procedure. If another six-year-old boy simply tries to grab your wig, that's fine too. You toss a ball with him. You deal with him one-on-one and relate to him on his terms.

Same thing goes with adults. It doesn't matter if you're talking to truck drivers, professors, presidents (which I would soon have the opportunity of doing), or dishwashers. You deal with them one-on-one and relate to them in the way that makes sense to them.

I worked on a radio show with Jimmy Durante, one of my favorite comedians. He would tell a story and as everyone cracked up with laughter, he'd say, "I've got a million of them, so why did I use that one?" It's because he knew which bits worked with which

listeners. He didn't repeat the same tales over and over again, oblivious to who was there. He dealt with each performance and audience individually.

Dealing one-on-one.

Relating.

So after two days of Bozo boot camp, Willard and I went back to the station manager's office at WRC-TV. He waited outside while I talked with the station manager and then we called him in. He Bozo-strutted into that office and said, "Howdy! It's your old pal Bozo!" After telling a few jokes and dancing around a bit, the station manager burst out laughing, convinced I really could clone a clown.

"You did it!" the manager said as he shook my hand. "Willard is our Bozo. We want to go on air. You'll launch in two weeks."

In what should have been a triumphant moment, Willard's face fell.

"We can't be ready by then," he said. "I need more practice. We need to write some routines and material."

"So what's the problem?" the manager asked. "You've got fourteen days."

"I'm getting married. I'm going on my honeymoon. I'll be gone during that time."

The manager lit a cigarette and leaned back in his chair. "I hear the City of Angels is lovely this time of year," he said.

"What do you mean?"

"Look gentlemen, either we're going to do this show or we aren't. Willard, you take your blushing bride to Los Angeles. Or leave her here. I don't care. The bottom line is this: you spend your honeymoon with Mr. Harmon, and come back ready for the show or else I'm not putting it on."

Understandably, Willard needed to talk to his fiancée about the whole situation. I am always optimistic, but I didn't see how

this could possibly work out. There was no way any sane man would choose to spend his honeymoon working in a television studio.

"We'll see what Willard says," the manager told me. "I just need to know we're doing this thing. I have an opening in the schedule and I need to fill it. I can't be waiting around."

I thanked the station manager and trudged back to my hotel. I had just enough time to pack my bags, grab a corned beef sandwich at a nearby deli, and head to Washington National Airport. At the terminal, I slumped in the chair and tried to think of alternate ways to make this thing work. But nothing came to me. We had lost the Washington, DC, market. I never doubted that we could make it work somewhere, somehow, at some point in the future. I was just drawing a blank.

I must have fallen asleep because the blond woman who'd checked me in for the flight nudged me on the shoulder and said, "There's a call for you, Mr. Harmon. You can take it at that courtesy phone over there."

On the line was Willard Scott, saying he was willing to spend his honeymoon in Bozo makeup at our studio in Los Angeles, perfecting his portrayal of the character.

And that's exactly what happened. Three days after he got married, Willard came out and spent his honeymoon with me in Los Angeles. During the day, we worked on Bozo material at the KTLA studio and at night I showed him all the hotspots and sights.

I had traded in my baby blue Cadillac for a red model with leopard-skin upholstery and huge fins. The singer and actress Pearl Bailey adored that convertible. We knew each other from around town and she invited me to stop by the set one day for lunch.

"Is that yours?" she asked when she saw the car.

My mouth spread into a big grin and I said, "Pearlie Mae, that surely is mine."

She threw open the door and slid down into the seats. "I want to ride all the way back to Philadelphia, cruise up the street where I used to live, and say, 'Look at this motor vehicle here!' "

Willard was equally fascinated by the car. We would ride down Hollywood Boulevard with him beside me in the front seat. There was a microphone and a loudspeaker in the car, and when I'd see a group of kids waiting to cross the street, grab the mic, and say, "Howdy! This is your old pal Bozo!"

When Willard took the mic and got the same reaction as me, I knew he was ready.

After two weeks watching our show, learning, and writing his own routines and scripts, Willard was ready to return home as Bozo the Clown. I dropped him off at the airport loaded down with the official costumes I had custom-made here in Hollywood. I honked the horn and waved as I sped off in my convertible.

Little did I know that I had just given birth not to one clown but two. A few years later, a local McDonald's franchise asked Willard to come up with a commercial spot for them, and he created Ronald McDonald. He would recall years later, "There was something about the combination of hamburgers and Bozo that was irresistible to kids."

All these decades later and my old friend still periodically appears on television, still making people happy. When he announces the birthdays of his listeners on *The Today Show*, you can see he cares about each one. Whether you're Bozo the Clown, a weatherman, a teacher, a waiter, or the president, it's all about relating to people.

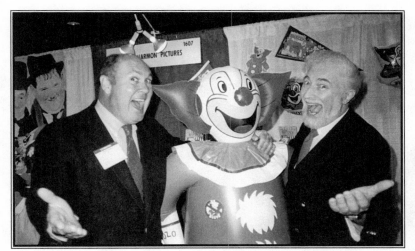

Willard Scott and Larry Harmon

PART II · The Bozo Adventures

"Just Keep
Laughing"
Your Old Pal,
"Bozo"

Signed publicity still of Larry Harmon as Bozo

3-D comic book of Larry Harmon's Bozo from 1987

Spanish version of Larry Harmon's Bozo comic book from 1974

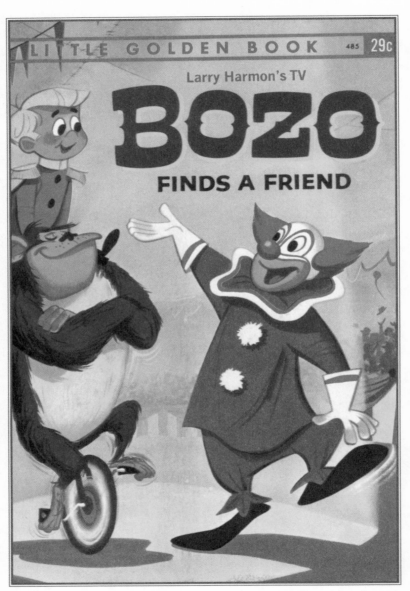

Children's book featuring Larry Harmon's Bozo from 1962

Scenes from a Larry Harmon's *Bozo the Clown Cartoon* from 1958

A few of the many Bozo the Clown collectibles produced over the years

Well, that's all there is for now, kids.

'Bye, Bozo.

"I began to worry that he was screaming for his pals to put the kettle on the boil."

BOZO

AND THE

CANNIBALS

IN

AN AMAZING ADVENTURE AT THE EDGE OF THE

WORLD

IN JUST A COUPLE SHORT YEARS, MY ANIMATION STUDIO HAD REALLY TAKEN OFF. AT ITS HEIGHT, FOUR HUNDRED PEOPLE WORKED TO CREATE CARTOONS. WE STARTED WITH THE BOZO CARTOONS TO ACCOMPANY THE LIVE-ACTION BOZO SHOW. BUT OVER TIME, WE PICKED UP WORK FOR OTHER CHARACTERS AS WELL. WE DID SOME CARTOONS FOR POPEYE, MR. MAGOO, TINTIN, DICK TRACY, AND OTHER GREAT CHARACTERS AT MY STUDIO. SO I DECIDED TO GIVE BOZO SOME PERMANENT FRIENDS. I HAD MY EYE ON TWO CHARACTERS WHO HAD KEPT AMERICA IN STITCHES THROUGH OVER A HUNDRED FILMS: LAUREL AND HARDY.

I had met Stan Laurel some years earlier and always looked forward to interacting with him. Contrary to his on-screen persona, Stan was hardworking and intelligent. I loved his quirky sense of humor and enjoyed getting laughs by doing impersonations of him.

Oliver Hardy had passed away in 1957, so Stan was kind of alone with the memories of his great entertainment career. He lived in an apartment down by the beach and spent his time at a typewriter, writing extensive letters to fans. He really cared about all the people who supported his career over the years and if you were to write him a short note, he would always respond. Stan also entertained a string of comedy greats in his apartment who came to pay their respects, including Jerry Lewis and Dick Van Dyke.

In 1961, I finalized a deal with Stan and Oliver Hardy's widow, Lucille, and purchased the rights to the Laurel and Hardy char-

acters. My initial plans were to use the comedy duo in a series of cartoons that would introduce their greatness to a new generation of viewers. Those cartoons were produced with Hanna-Barbera in the mid to late sixties, and then in the early seventies we did some *Scooby-Doo* tie-ins.

In the meantime, Bozo the Clown was spreading across the globe. Race, language, and cultural barriers didn't seem to exist for this character. No matter where we went, people related to the love and laughter Bozo presented. We had a show that was huge in Thailand. At one time or another, we were on television in Greece, Puerto Rico, Mexico, Brazil, and many other countries. Our success was so great, I began to think Bozo could be accepted by any group of people, anywhere.

So when I was in Australia finalizing the launch of a show there (which would eventually be watched by almost everyone with a TV in Australia, plus probably some kangaroos and koala bears), I decided to put that theory to the test: I asked the Australian government to take me into the desert to meet with the nomadic Aboriginal people who still travel those dusty lands.

Though I was worried that the humor wouldn't translate and the character would be too extreme, the Aborigines turned out to be not only the most welcoming people I had ever encountered but also one of the most responsive audiences I'd ever performed for. From little children to old women, most of them liked me as much as I did them.

They taught me dances that were thousands of years old. They showed me their weapons *(Fig. 11A)*, honed over the eons. One day, we all danced and laughed and sang. And the next day, they were gone. There wasn't a soul left. A hundred and fifty, maybe two hundred people, just dissipated into the desert *(Fig. 11B)*. I didn't know if I'd ever see them again, or if they might show up a year later as if no time had passed.

Fig. 11A

Fig. 11B

During those days in the Australian outback, I heard people mention the wilds of New Guinea. Here I was, surrounded by nomadic tribes with spears and sand and heat for as far as the eye could see, and all the locals acted as though we were strolling along the pier in Santa Monica.

"If you want to see wild," they sneered, "go to New Guinea—although you're not likely to come back to tell us about it."

Back in my hotel room in civilization, I thought about how easily I had been accepted by the Australian Aborigines. Bozo connected with them just as he did with kids in the Chicago suburbs. Was there any limit to this character's abilities to relate? Was there any place so remote he couldn't penetrate? If I could go back in time, was there any era in which he couldn't flourish?

As a child in Cleveland, the only way I could see something fascinating, exciting, or exotic was to look in *National Geographic*. They had these great pictures of everything: animals, people, remote places I couldn't even invent in my imagination. I remember one morning when I was seven or eight years old, waiting by the door

for the mailman to drop off the latest issue. In it, I saw pictures of a place called New Guinea that the magazine claimed was one of the most primeval places in the world, where natives lived a pre-civilization, almost Garden of Eden-like existence. Their customs hadn't changed for tens of thousands of years. As I traveled the world spreading Bozo to different communities and cultures, I never forgot about the jungles of New Guinea and what seemed like a land that time forgot.

As I lay in bed in my hotel room in Australia, I thought about how close I was to those wild lands that had intrigued me as a child. And now I had a costume that crossed all borders. Bozo could protect me. Bozo could be my guide, my entrée into a new old world. So I decided to risk my life to see if this character could relate to cannibals.

I also had a crazy idea that maybe I could solve a mystery.

Michael Rockefeller *(Fig. 11C)*, son of New York Governor (and later Vice President of the United States) Nelson Rockefeller, had gone missing in New Guinea in November 1961. It was a huge news

Fig. 11C

story and some people speculated that he had drowned. Others wondered if he had been eaten. Still other folks thought he was hiding in the jungle, living a Robinson Crusoe-type existence with the locals *(Fig. 11D)*, who he'd been studying as part of an anthropological expedition. It was a long shot, but I hoped that maybe I could discover what had happened to the lost adventurer and bring some consolation to his grieving family.

The Australian government wanted no part of my experiment. When I met with them in the capital of Canberra, they told me I

Fig. 11D

was crazy. "You know what you can do?" the bureaucrat said. "You can put that idea out of your mind. That's not where you want to go, mate."

The more he told me it was a ludicrous and dangerous idea, the more determined I became.

"I bonded with the Aborigines in the Outback, didn't I?" I asked him.

"That's a completely different thing," he argued. "Those Aborigines may seem primitive, but they have interactions with us. They work with the government. They've seen modern men. But the tribes up in New Guinea, many of them have never encountered *any* civilization. They'll eat you as soon as look at you."

We sat in that government office and argued as the afternoon drew on. He didn't realize this wasn't a publicity stunt or an attempt to make headlines. It was about challenging myself.

You see, I am what Bozo is. And Bozo is what and who I am. There's no separation. The clown exemplifies my attitudes toward love and laughter and living life to the absolute fullest. I cooked up this crazy idea of taking Bozo to the cannibals because I wanted to see if his laughter was a universal language. But now, looking back at that fateful day, I realize that on some subconscious level, I was

not just testing the effectiveness of a costume and a wig, I was testing my own strength, courage, and deep-seated belief that humor, compassion, and caring can bring people together.

The government official must have realized he was dealing with someone who would not be deterred—or maybe he just wanted to get this lunatic out of his office. But, either way, he started to relent.

"We'll give you a letter," he said. "And that letter says we are not responsible. You'll get no help from us—no guns, no soldiers, no airlifts. You'll have to secure your own travel into the jungle. You'll have to survive in the best manner you think you can. And if you make it—and I don't think you will—we'll welcome you back."

Though I now had an official letter of passage in my pocket, I still had to find a way (*Fig. 11E*) to reach one of the most remote areas on Earth.

Fig. 11E

Back then, you didn't just log on to some computer to book a flight to New Guinea as you would today. Heck, the U.S. State Department *still* has travel advisories and security warnings about going there. So I had to do a lot of independent research to find the type of guide who could transport me into the wild.

That research ultimately led me to a dive bar in an industrial neighborhood near the airport in Canberra. It was dark and reeked

of stale beer and God knows what else. The bartender pointed at a blond-haired man in bell-bottomed jeans slumped in a booth in the back corner.

The bush pilot introduced himself as Kearney. "I'll be needing payment up front, then," he said after I explained the mission. "'Cause you ain't coming out of them jungles, mate. And I'm not going to be trying to collect my wages from no picked-over skeleton."

Darryl Zanuck, Jack Warner, Robert Evans—you name a powerful Hollywood mogul and I had haggled with him. I was entirely comfortable swimming with sharks, so reeling in this little Australian fishie was no problem. I told him I wasn't going to hand over my entire bankroll, because then he'd have no reason to return to pick me up. He could just leave me to die. So, instead, I negotiated an installment plan that ensured a round trip.

Kearney's dilapidated plane sounded like a screwdriver in a garbage disposal. It had just this one little motor. I've seen lawn mowers with bigger engines than that thing. And the ride felt like a tin can in a tornado.

We were crammed in there with a cameraman and a sound guy I'd hired locally to document my trip. At first, all they could think about was a little change in their pocket and the opportunity to work with someone from Hollywood. But as Kearney and I talked, and as we flew over miles and miles of nothing but the dark blue of the Pacific Ocean, they were probably starting to wonder if their ambition had gotten them in over their heads.

All the while, I worried that my own ambition would cause me to lose mine. "Your head'll be on a stick before nightfall," the Australian bureaucrat had warned.

"There's no ambulance gonna come rolling up with sirens blaring to save your hide, ya know?" Kearney scoffed from the pilot's seat. I could see him peeking out of the corner of his aviator

sunglasses at me. "Ya gotta take that wig off, mate. It's blocking me view."

Yes, I was jammed into this rickety contraption, heading into the jungles in search of cannibals, sporting my full Bozo costume. At least I would be able to use my clown shoes as flippers if the plane crashed into the ocean *(Fig. 11F)*.

Fig. 11F

We refueled in New Guinea's capital, Port Moresby, and then headed for Mount Hagen, a mountainous region at about 8,000 feet of elevation straddling the boundaries of the Enga and Western Highlands provinces. I tried to block out the rattle of the airplane's engine as I looked at the lush forests below. Such vibrant greens, roaring waterfalls, and jagged rocks! Here I was, a kid from Cleveland, Ohio, in a Bozo suit, looking down on the beginning of our world. It was just so beautiful.

But it was also frightening. We had been flying over jungles for hours. And I hadn't seen so much as a concrete house in all that time. Nothing. No people, no buildings, no roads, no television studios. Just jungle.

"Get a good view now, mates," Kearney said. "You might not get to see it again."

I wanted to be irritated at his constant taunts. I should have told the Aussie to button it. But what I actually admitted was, "If you're trying to scare me, you've succeeded."

At that, Kearney softened a bit and started giving me information that would help me survive in the wild. "These people you'll encounter, they've existed for hundreds of thousands of years because of their spears," he said. "You'll see weapons that might as well be a thousand years old. They haven't changed at all. They don't need to. They're plenty deadly as is."

Kearney banked the plane to the right and I looked down over a tremendous waterfall. The water was so clean and clear that I could see the smooth rocks that lined the riverbed. Huge flocks of colorful birds exploded out of the trees as we thundered overhead.

"The secret is, mate, ya gotta look at their wrists," he said.

"Huh?" As much as I wanted to absorb the beautiful scenery, I needed to concentrate on his every word; any tip might save my life.

"It's their wrists. They hold the spears upright, vertically, with the points near the ground. If their wrists start to quiver, it's like when a gunslinger's fingers tremble before he pulls his weapon. They can pierce your Adam's apple from fifty yards away. If you see the wrist quivering, chances are, you've had it. You're gone. *Adios amigo!*"

We circled above a clearing in the jungle where the grass was tall and the land looked flat. "Much of the country speaks Tok Pisin, but there's a wide variety of dialects and tribal differences," he said.

"Can they speak clown?" I asked.

"I dropped off some scientists down there before, but they never came back," Kearney said as he pointed to the clearing. "That's the safest place to land, and it's as far as I'm willing to go. There's nothing past here but savages and God. And even He's scared to walk them jungles."

The mountains towered above us as we descended below the ridges and plummeted toward the clearing. The landing felt and sounded like a metal barrel full of rusty nails being dropped from a ten-story building *(Fig. 11G)*.

Fig. 11G

As we unloaded our gear from the plane, Kearney mopped his brow and chugged from a bottle. I told him to return in two days. "I'll be back here at noon," he said. "I'll wait one hour. If you don't show up within an hour, then you're dead. They ate you. So long."

He climbed back into the cockpit and the plane's engine coughed and sputtered and finally turned over. We watched the plane barrel down the clearing and then struggle into the air, missing the tree line by inches. As the roar of the engine faded into the distance, I felt my world disappear. We had no phone, no radio, no weapons, and our last connection with the modern world was heading out of sight into the blue.

As I've traveled the world throughout my life, I've learned that certain locales have a very specific, very particular scent. It belongs there, to that land and to that people. And in the clearing, surrounded by the jungles of New Guinea, I was overpowered by a scent of fresh flowers mixed with the putrid foulness of decay. This wasn't a manicured exhibit in some Metropolitan natural history museum. Creatures lived and died in this jungle every day, their remains left to steam and rot in the oppressive heat and humidity.

"Where do we go now?" Peter, the sound guy, asked. "Maybe we should just stick it out in this clearing. The locals probably aren't

going to bother us, not with you all decked out in red, white, and blue and clown makeup. The worst thing we'll come up against is these mosquitoes trying to eat us alive." He slapped at his arm and waved his hand in front of his face to drive off the devilish insects.

Ian, the cameraman, optimistically agreed. "Too right. That sketchy bush pilot was just trying to angle for a higher fee with all them tales. Don'tcha think, Bozo?"

I didn't reply because I was staring at a wrist about a hundred yards away.

Watching to see if it quivered.

As the crew jabbered on, a native tribesman had soundlessly appeared at the edge of the clearing. Suddenly, he was just there—with spear in hand.

He was slender, but with tightly coiled muscles. He wore a sarong-type garment that reached from his waist down to his ankles; I would later learn it's called a lap-lap. A circular bone ornament hung from his nose. His headdress was highlighted by a tall plumage of red feathers that reminded me of photos of the birds of paradise that I'd seen in *National Geographic* as a child. His face was expressionless and gave no indication of what he thought of our intrusion onto his land.

I glanced at my crew of two. They were oblivious, busy talking among themselves. So it was up to me to do something. But what? I couldn't dash for the jungle because not only would he pick me off like a sniper having a bit of target practice, but also my Bozo shoes weren't made for sprinting. On the other hand, I couldn't just stand here in the middle of this clearing. I had to do something, and instinct suggested I spread my arms wide, with my hands open.

I figured I'd show him that I came in peace, that I had nothing to hide. If he thought I had some sort of weapon, he would kill me

in a second and that'd be the end of the story. I took two, maybe three steps forward, then stopped.

He did the same thing.

I took three more steps forward.

And so did he.

Our procession seemed to take hours. Two steps. Pause. Two steps. My red shoes slapped the ground. His bare feet landed without a sound. My arms remained extended; his spear remained firm in his hands. A gentle breeze rustled both my wig and his headdress.

People talk about lives flashing before their eyes in times of crisis. Or in the movies they show a flashback to a happy time when the hero remembers eating ice cream at a picnic with his high school sweetie right before he dies. None of that happened for me. I was completely focused on his hand—and the pointy object it was holding. By now, the crew must have noticed what was going on, but I had completely tuned them out. I had no idea whether they were rooted to the ground in fear or running for cover.

Two steps. Pause. Two steps. He was so close I could smell him: a sweet, pungent, lardlike odor. And in my costume and wig, I probably reeked to him as well. Suddenly he was in front of me. We were face-to-face: a clown painted in white makeup and a New Guinea tribesman painted in earth pigment. I didn't budge and he didn't, either. My mind was racing, trying to think of a way to stay alive.

I glanced at his headdress and then I noticed he was looking at my wig. He said something. It was guttural and completely unintelligible to me. But my whole life I've been doing impersonations, so without thinking, almost by reflex, I repeated exactly what he said, as I used to do with Stan Laurel. He probably thought I was

129

crazy, but he said something else. And I repeated that, with exactly the same pronunciation and inflection. God knows what I was saying, but it was pouring out of my mouth.

He pointed to himself and said something that sounded like "Konato." For all I knew, that might mean "banana split with extra whipped cream" in his language. But I somehow felt like he was telling me his name.

Konato motioned for me to turn around. My heart plummeted. In spite of the heat and sweat, my whole body went cold—I felt sure he was going to run me through with his spear. As I slowly turned around, I saw Ian and Peter, who hadn't budged from the spot where I last saw them talking. Except now they were staring at me, their eyes wide in horror.

A few seconds passed, but it felt like hours. I looked back over my shoulder and saw Konato turning around himself, mirroring my movement. Maybe he wasn't going to stab me in the back after all. Maybe he just wanted to see my costume—and then show me his. We twirled around in this surreal fashion show until we faced each other again.

I pointed to his red headdress and the gorgeous bird of paradise feathers. I made some guttural noises that sounded like his language. Then I raised my hands to my red wig.

His eyes grew big.

I pointed to his headdress, and then pointed to my wig. I made this gesture repeatedly, until I felt he understood. I needed to relate to him, to get him to see me as a friend or an equal. Maybe he'd think I was from a neighboring tribe, one with really good sunscreen. Maybe he'd even think I was their chief.

He leaned his head back and let rip a blood-curdling howl that went on longer than most opera singers can hold a note. It dawned on me that I may have succeeded in making him think I'm the

leader of a tribe, but what if he thinks it's a rival or enemy clan? I began to worry that he was screaming for his pals to put the kettle on the boil *(Fig. 11H)*.

Fig. 11H

People suddenly materialized along the edges of the clearing. Twenty, thirty, fifty, maybe sixty of them—their faces all painted with natural pigment. Some wore lap-laps, others were completely naked. But they all carried spears. There was no way I could keep an eye on that many wrists.

As the tribe started closing in, Peter and Ian rushed over to where I was standing. I wanted to yell at them for acting so crazy, but I realized what was more important in that moment was to find a way to relate to these tribesmen. Connecting and communicating with people of different ages and nationalities was how I'd spread Bozo around the world, but now my life depended on it.

I kept pointing to Konato's headdress and then to my wig, grinning my big Bozo smile, to try to get him to see that we were really the same. Sweat and makeup poured down my face as the natives edged closer with every second and my crew cried and babbled in panic. They began to form a circle around us so tight that all I could see out of the corners of my eyes were spears, smeared flashes of color, and teeth that might be chowing down on me shortly.

And then...there it was...a slight, almost imperceptible...smile!

131

Konato addressed the crowd then pointed at me. He must be the leader, I realized, because none of the other natives were wearing bone ornaments like his. He gestured to my red nose, almost touching it, and then spoke some more. Then his fingers grazed the ends of my wig. The mob murmured in what sounded like agreeable tones. Finally, he pointed to my shoes and the crowd gasped.

He looked me in the eye and flicked the tiniest glint of a smile, and then he turned and walked off as the mob parted to let him through.

"What's he doing?" Peter said frantically. "Where's he going?"

"He pointed out the parts he wants them to save for him!" croaked Ian. "He's eyeballing Larry's nose, feet, and wig!"

Konato then yelled, motioning for us to follow him into the jungle. The crowd surged forward. My heart sank as I walked into the unknown.

The natives led us up the most grueling path—if you can call it that—I'd ever had the misfortune of stumbling on. Most of it was uphill at an incredibly steep angle. My shoes crumpled in half as I struggled up the incline. The altitude and difficulty of the terrain made me wish they had just wanted some fast food back in the clearing and gotten it over with.

Pushing aside foliage as we walked, I heard surprisingly familiar noises in the distance—dogs barking and kids yelling. We stepped out of the trees and a cool breeze hit me in the face. It was like walking through a curtain; suddenly, I was onstage in their village.

The grass was worn down to dirt. Huts and small fenced areas were scattered haphazardly. I could hear a few pigs grunting, and the air was thick with the stench of sweat and dirt. Konato quickly strode into a hut, saying something to a short, heavyset woman standing nearby. The woman offered me raw peanuts pulled from the ground.

"Are they trying to fatten us up?" Peter asked.

"No, they're adding flavoring," Ian shot back.

The group motioned for us to sit. In my costume, I can't sit with my legs crossed, so I stretched them straight out in front of me and surveyed my appearance. My costume was filthy and my face streaked with sweat. The yak hair in my wig seemed to have absorbed every scent and smell since we'd landed. Every time I moved my head, I got a blast full of stench. As I looked down my legs to see my size 83-AAA shoes sticking straight up, it occurred to me that they were almost the same height as a small tombstone.

I made eye contact with some of the children in the mob that was quickly gathering around us. I smiled and grinned and waved to them. It was just a natural impulse. I'd spent my life entertaining and relating to children and I'd keep doing so, regardless of how dire my circumstances might have seemed.

Suddenly, the group parted and Konato walked into the circle. He shouted, and the people all scattered into a flurry of activity. Women put pots and cooking utensils on the fires dotting the hamlet's perimeter; men began setting up for some sort of ceremony and reapplying face paint. In just a few minutes, they seemed to be prepared. But prepared for what?

"This could be it, boys," I told my Aussie crew.

And then the people of the village started dancing. There was such joy and happiness on their faces. The music was wonderful, and they pulled me to my feet and started teaching me their dance movements. It wasn't Fred Astaire, but it was much more fun than being boiled alive. Women brought out fruits and vegetables and lay down a spread of food in front of us.

Eventually the dancing stopped and Konato addressed the crowd. I had no idea what he was saying, but I'd seen enough keys to the city be given out by mayors to have a general idea. It was an official proclamation, like when a politician introduces a guest to the town.

When he was done, Konato pointed to me and the crowd cheered. Suddenly, children began rushing to my side as the women pushed food toward my Aussie crew. For the first time since we'd landed in New Guinea, I felt safe.

I played with the children, showing them my own dance moves. "A one and a two, and an old tennis shoe!" I said as I counted out the steps. That quip always got laughs in America and, though there was no way these children understood it, they giggled just the same.

I whipped out some simple magic tricks, starting with a basic sleight-of-hand illusion using a smooth brown rock from the dirt at my feet. Konato came over and watched intently, and then he tried to copy the disappearing trick but messed it up. So I demonstrated the proper way to palm the rock and hide it, and Konato giggled with laughter. He dashed off, and soon I saw him performing the magic trick for others around the hamlet. They howled with surprise as they struggled to figure out which hand held the rock.

I had proven my theory: People may have cultural, economic, and political differences, but at the core of our being, we really are all the same. When I did magic tricks, danced, or made funny faces for the kids, the look in their eyes was exactly what I saw everyday in Los Angeles, Chicago, or New York City. Joy, laughter, and human bonding—the tools we use to relate to one another—are as universal as a head, hands, and feet.

I later learned that the dancing and feasting was called a sing-sing. It's a traditional celebration in New Guinea: the tribe was welcoming us into its midst. We danced for hours and ate until we thought we would burst. Konato gave us a hut to sleep in, and the next day he proudly showed us his tribe's pigs, agricultural tools, and hunting skills. We were given a complete tour of native New

134

Guinea life. As a student of humanity, I gorged myself on every detail, desperate to take it all in.

We developed a method of pantomime that allowed us to communicate in a rudimentary way. I was able to learn from him that missionaries and researchers rarely moved through this part of the jungle. But I couldn't get any details on Michael Rockefeller. All the ways I might describe the young adventurer were impossible to communicate in our basic game of charades. How do you symbolize money to someone who doesn't need it? How do you explain our Western interpretations of wealth and status? Konato was used to judging affluence by feathers and the amount of pigs you owned. A Rolex, a nice camera, and a famous last name meant nothing to him.

When it regretfully came time for us to leave, Konato did not journey back to the clearing with us. He walked to the edge of the village and addressed me. His body language and tone suggested he was saying good-bye. Our guides then led us into the jungle, the villagers waving as we disappeared into the forest.

Kearney had unbuttoned his dirty white shirt and was waving it to generate some breeze. He was leaning against his plane as I stepped into the clearing with the Aussies. He practically choked on his drink when he saw us walking toward him.

"You made it!" he exclaimed. He shook our hands and patted me on the back. He seemed genuinely happy to see us. As the plane lumbered into the sky, I started telling Kearney about our experiences. I didn't discover anything about Michael Rockefeller, but we had seen and learned so many other things. Kearney may have possessed many skills, but he lacked the most important ones, the ones that had enabled me to survive the jungles of New Guinea: the ability to relate, to make people laugh, to bring joy into the eyes of children and, thus, their parents.

135

I now knew that Bozo truly could fit in with any group of people anywhere. They might not understand what I was saying, but they understood my laugh and my smile. Even in the most remote, most dangerous places on Earth, laughter made life worth living. Laughter is the medicine that heals us all. And I am, after all, the doctor of laughter.

"That's a ripper story you've got there, mate!" Kearney exclaimed when I finished relating the tale. "I've never heard anything like that in my life."

"I'm just lucky," I said, staring reflectively out the window at the vast blue expanse of the Pacific.

"How's that?"

"I'm lucky that none of them had a recipe for clown à la carte!"

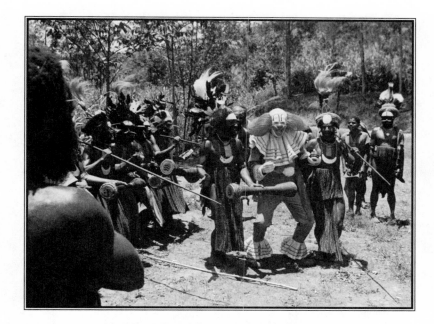

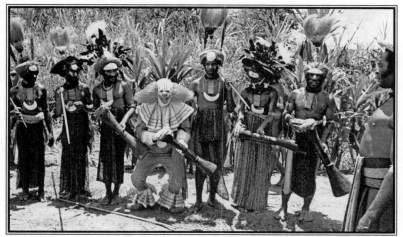

Larry Harmon as Bozo in New Guinea

AN AMAZING ADVENTURE AT THE EDGE OF THE WORLD

"The only thing I had pulled on planes was a few practical jokes with the flight crew."

BOZO

AND THE N... **AND THE** **U.S. AIR FORCE**

THE **VOMIT**

COMET

RIDE

O N MAY 25, 1961, THE IDEA OF SPACE REAPPEARED IN THE FOREFRONT OF MY DREAMS AND ASPIRATIONS.

Smarting over the Bay of Pigs fiasco, watching the Soviet Union reach major space exploration milestones, and sensing the coming racial strife and turmoil that would face our country, President John F. Kennedy addressed Congress to issue a bold challenge.

"I believe that this nation should commit itself to achieving the goal, before this decade is out, of landing a man on the moon and returning him safely to the earth," the president said.

It was a shocking suggestion. And the costs would be staggering. The space budget was forty cents per week for every man, woman, and child in the country. But the American people were willing to make the commitment.

I vividly recall the day eight years later when Kennedy's dream came true. I was in El Paso, training a couple actors to portray Bozo and we were listening to the television late at night. It was way past midnight when we saw the news report that Neil Armstrong had walked on the moon *(Fig. 12A)*. We all cheered and patted each other on the shoulder, proud to be Americans on such a historic day.

But as I traveled the world as Bozo the Clown, I found that many people didn't understand the images they were seeing from space.

140

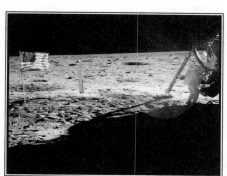

Fig. 12A

"Why do the spacemen float around like that?" children would ask me. "Why do they walk so funny in those space suits?" I knew parents and teachers sometimes struggled to explain zero gravity to the kids. But scientific explanations frequently don't make sense to a small child. Especially when adults don't fully comprehend the subject either.

But they understand Bozo, the world's most famous clown, I thought. Highly decorated pilots and NASA engineers don't mean anything to kids. But their old pal Bozo does!

The hairs on my neck stood up and I got goose bumps, just like I do whenever I get one of my crazy ideas. I knew I was on to something good, something that would make children the world over understand the concept of zero gravity. And, in the process, turn the make-believe dreams I had in that cardboard box as a child and on the *Commander Comet* set as a young adult into reality.

Bozo the Clown would go to space!

It seemed impossible. But so did the idea of cloning clowns and other things I had accomplished in my career. So many of my amazing adventures seemed impossible at first glance. But through hard work, perseverance, and a stubborn refusal to take no for an answer, I made them all happen.

If you find something you love, something you're passionate about, and you pursue it with every ounce of strength in your body, nothing is impossible. Because it won't seem like work. Instead, it'll be a challenge that you relish.

That's what getting into space was like for me. Sure, there was government red tape along the way. But that's just an opportunity to make a new friend! When I encountered some surly bureaucrat, instead of getting discouraged, I just challenged myself to make him laugh and to brighten his day. When I ran into a paperwork obstacle, I studied the terminology very carefully until I found a loophole or a way around it.

And next thing you know, Bozo was going to space.

But I had to survive the training first. And that wasn't easy.

In the late 1960s, Wright-Patterson Air Force Base in Dayton, Ohio, served as a training center to the nation's most accomplished pilots who strived to break free of Earth's grasp. So that's where they sent me.

I peeked in a classroom and saw row after row of crew-cut men with the unmistakable military bearing that comes with years of dedication and determination. They wore blue pilot jumpsuits and sat in desks, ready to handle whatever was thrown at them. These were men comfortable with barrel rolls, heat-seeking missiles, and evasive maneuvers high above the ground. So nothing in this classroom could surprise them.

Except for when a clown burst into the room.

I pushed open the door and walked into the class. The pilots didn't say a word but their eyes darted around, looking for something that would explain my presence. I took a seat and my giant red shoes slid all the way under the chair in front of me and bumped the feet of a blond-haired pilot with a thick neck. He turned around to face me.

"Howdy! It's your old pal Bozo!" I said. "Sorry for bumping into you there. When's recess?" He didn't seem to get the joke.

Soon, a bald-headed man threw open the door, followed by a guy wearing a lab coat with a stethoscope around his neck.

"Okay, listen up," the bald guy barked. "When you go into the chamber, you better keep your heads on straight or you won't come out alive. You'll have an oxygen mask that you can put on at any time. However, the point of this examination is to see how well you perform under great amounts of pressure with minimal oxygen. So putting on that mask may save your life, but it'll cost you ranking spots on the examination chart."

The doctor meekly stepped forward. "Gentlemen, there are two physical manifestations that will indicate you are suffering adversely from the low oxygen, high pressure environment. One, your lips will turn blue. Obviously, you cannot see your own lips, but you should help your colleagues and keep an eye on theirs. Two, you will not be able to generate enough lung capacity to whistle."

The bald guy continued: "Once that door is locked and the air is pumped out, we may not be able to get to you in time. If you get into trouble, or you see someone getting into trouble, you damned well better get that mask on your face."

He gave us each a clipboard and papers, a pencil, and an oxygen mask. A massive metal door clanged opened at the back of the room and he told us to double-time it through the portal. Certainly, I had experienced my share of military-style rushing around in World War II, but that was in combat boots, not Bozo shoes, so I stumbled a bit. Next thing I know, the bald guy was standing next to me, smirking. The nametag on his flight-suit read Lieutenant Kilbourne.

"I know the brass okayed this, Bozo," he said. "But I'm not cutting you any breaks. You wanna go to space, you train just like everyone else. And you face the risks, just like everyone else."

I'll admit that I was scared. All the rest of the men in that room had flown at top speeds and pulled multiple G's in the most advanced aircraft in the world. The only thing I had pulled on planes was a few practical jokes with the flight crew.

But I wouldn't have had it any other way. I wanted to take on the full challenge: no shortcuts, no celebrity treatment. I would prove myself based on my own merits. I stepped through the door and into a long, metal tube. A bench ran the length of the tube on either side and the pilots had taken their seats. I found an open spot and sat down.

"I'll watch your mouth if you watch mine," I said to the guy next to me. "Don't let my lips turn blue!"

"Your lips are painted red," he sourly replied. "There's no way I can tell anything. You're on your own."

Kilbourne's voice crackled over an intercom. "Answer as many questions as you can," he said. "Once you complete the test, put your papers down. If you need oxygen, then put on your mask. When you do either of those things, you are finished with this exercise. Start your examinations . . . now!"

Everyone in the tube went to work scribbling on the papers, jotting down formulas, and frantically trying to answer the math problems. I could hear some sort of pump engine running. Through the thick metal walls, the engine sounded far away. But soon enough, I felt the effects.

They were sucking all the oxygen out of the room. It was like wrapping a blood pressure cuff around your whole body. I looked around and saw some of the pilots looking nervous, a few of them sweating. I quietly blew air out my mouth, silently whistling the old standard "Blue Moon" to myself, and got back to my test. I quickly got lost in the concentration of trying to solve those complex math questions after so many years away from tests and exams.

144

Several pages of examination questions later, I looked around the tube. A few men were still scribbling away. Most had placed oxygen masks over their faces. I figured I needed to hurry and complete the test.

And only then did I realize I could no longer whistle.

I put my fingers to my lips, but of course couldn't feel anything because of my gloves. I looked to the guy next to me on the bench. His head was tossed back, eyes closed, and he was breathing deeply through the oxygen mask.

I can *not* give up, I thought. There's no way I'm quitting.

I plowed through more questions. My head ached and I couldn't fill my lungs with air. I felt like an asthmatic under water. I focused on taking shallow breaths and tried to keep my wits as I struggled to complete the final queries. I was dizzy and struggling to stay awake as I finished the last one and lifted the oxygen mask to my face.

I wasn't the last one to reach for the oxygen. But I was close. And that was good enough for me. I gulped air as desperately as a man in the desert chugs water. And then the massive metal door creaked open and we were led out of the tube.

"Good job, Bozo," Kilbourne said to me. "Go to the Colonel's office. He wants to see you."

The office was spacious and impressive, without a single thing out of place. Colonel White stood and offered his hand as I walked in the door.

"After all our chats on the phone, it's good to meet you in person, Bozo," he said. I had spoken to him many times while navigating the red tape and approvals needed to authorize my Bozo mission into space. He had a warm voice, confident and strong. His face matched that voice, but also gave the impression that he wouldn't tolerate any foolishness.

"Let's face the facts, Bozo. You're probably not going to the moon. It's just too risky, too costly, and too difficult to pull off.

The administration won't approve that. But I'll get you into zero gravity, which is a hell of a lot more than most people experience."

Colonel White explained that even if we could make a full-fledged NASA mission happen, I would have to devote an additional nine months to training. It had been a dream of mine for so long, I thought, what's another nine months? So far in my life, nothing had proven to be impossible—just unlikely—so I told him not to count me out. Maybe I could pull off the unlikely.

In the meantime, I accepted his offer of experiencing zero gravity.

Astronauts go through a number of training mechanisms to acclimate them to the weightlessness feeling in outer space. Sometimes they train underwater. But other times, they replicate the feeling of zero gravity by flying in specially designed planes.

"But don't think that's going to be easy," Colonel White said. "They don't call the planes that create zero gravity 'vomit comets' for nothing."

The process, he explained, involved flying an airplane through a series of roller-coaster-like maneuvers called parabolas. These parabolas of flight would be carefully orchestrated to increase altitude at a 45-degree angle and then down at 45 degrees. By executing this climb from 24,000 feet to 34,000 feet and back down again, I would experience about 25 seconds of weightlessness.

My challenge, I realized as he spoke, was to do this without throwing up on camera.

Colonel White led me to the tarmac and we walked up the steps to a large plane. Inside, the seats had all been removed and the walls covered with padding. My camera guy attached his equipment to one end of the vessel's interior.

"You'll only get one chance at this, Bozo," Colonel White explained. "Maybe two. But we don't like to put people through more than that. Their bodies can't take it."

Lieutenant Kilbourne agreed to accompany me. We strapped into some makeshift seats on the sidewalls, and held tight as the plane climbed and climbed. Before I knew it, the pilot's voice came over the intercom and told us to unbuckle our seat belts and get ready.

And suddenly I was floating (*Figs. 12B, 12C*).

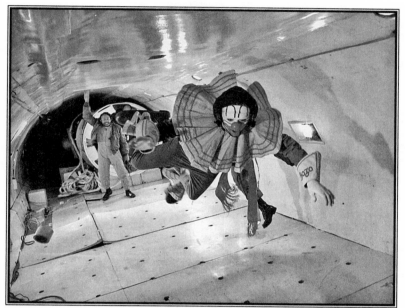

Fig. 12B - **Larry Harmon as Bozo in zero gravity**

People frequently compare zero gravity to being underwater. But that's not exactly true. Underwater, you can still feel the waves and tides. You feel the water on your skin. You feel air bubbles and pressure. So there's no way to escape the knowledge that you're in *something*. With zero gravity, you don't have that. You're just floating. In *nothing*.

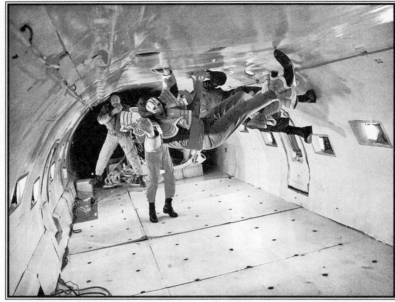

Fig. 12C - **Larry Harmon as Bozo in zero gravity**

Kilbourne and I tossed a ball back and forth to show how it floated the same way our bodies did. And then suddenly I was on the floor of the plane again. It was over so quickly.

"We have to do that again!" I said. Kilbourne got on the intercom and told the pilot to execute the maneuver a second time. So we floated around again. I tried to pour a glass of water and the liquid just hovered in the air. And then I was on the floor.

"Again!" I yelled. The feeling was exhilarating, unlike anything I'd ever experienced.

"That's it, Bozo," Kilbourne said. "Two times max."

I went over to the camera and acted like I was examining it. Then I pretended to be shocked and disappointed.

"But the camera didn't get it. The whole point of this flight is to record an educational film for children. This will all be for nothing without that footage."

Of course, the camera had been rolling all along. But I had to have more time in zero gravity. I had come so far, and faced exploding in that pressure tube like a hot dog in a microwave, to reach this point. I wasn't going to give up without experiencing as much as I could—and I knew we needed lots of video in order to create the best possible education materials.

Kilbourne relented and we went through more of those parabolas. Finally, he couldn't put off ground control any longer—and I must admit that I'd started feeling a little icky myself. Since I had makeup on, the camera couldn't pick up just how green I'd become.

"What the hell do you think you're doing?" Colonel White yelled when we were on the ground. "I told you idiots no more than two trips!"

I took the blame and told the colonel that it had been my fault because we needed the footage.

"Get this clown to the infirmary now!" he shouted to an aide standing nearby. "The Air Force is not taking any responsibility if you've injured yourself with that stunt, Bozo."

In the infirmary, as we waited on the doctors, a woman lay in a gurney. She was awake and said that she had broken her ribs in a training accident. I stood next to her gurney talking to her, telling jokes.

"It hurts to laugh," she said. "But don't stop. Tell me another!"

I went through the entire infirmary, chatting with patients and making them smile before I finally sat down to be examined. Nowadays, there are commercial versions of vomit comets that perform fifteen of the zero gravity parabolas. But they've toned down the

maneuvers to make it easier on the participants. Back then, there was real concern that I had inflicted medical damage on myself by going through eight bouts of zero gravity. Fortunately, the doctors declared me to be fit, and then suggested that maybe I avoid solid food for a couple hours.

So I went back to entertaining patients in the infirmary. Seeing those smiles and hearing that laughter made me remember my true mission. It wasn't to undergo nine months of rigorous training to go to the moon or Mars or wherever. It was to make people laugh. It would be just plain selfish to leave my business, my audience of children, and my laughs behind to go to the moon.

So like the comet that fades from view, my obsession with outer space receded. I got back to the business of Bozo and brightening people's days. And in the process of doing that, many years later, I ended up recording a song with my good pal William Shatner—someone who knows a thing or two about space. One of the lyrics he sang was, "When they find people in outer space, Bozo will love them, too." And I will. Whether it's old cartoon reels transmitted across the galaxy or me planting my Bozo shoes on the surface of a new planet, I'll be there. One day, I'll make it.

Larry Harmon as Bozo with the zero-gravity plane

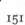

151

"I still have not ever heard anyone say. 'I like you. Bozo.' It's always *love*."

BOZO AND THE

NEW YORK CITY FIRE DEPARTMENT IN

A FOUR-STORY FALL

Larry Harmon as Bozo in fireman uniform

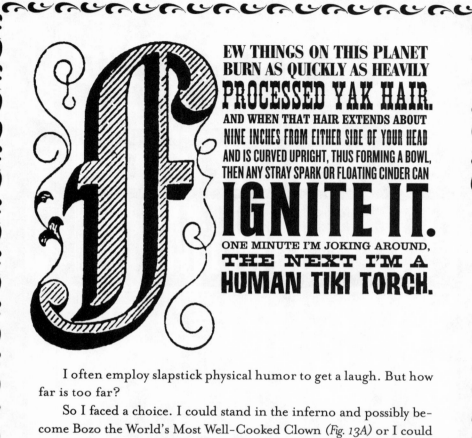

FEW THINGS ON THIS PLANET BURN AS QUICKLY AS HEAVILY **PROCESSED YAK HAIR.** AND WHEN THAT HAIR EXTENDS ABOUT NINE INCHES FROM EITHER SIDE OF YOUR HEAD AND IS CURVED UPRIGHT, THUS FORMING A BOWL, THEN ANY STRAY SPARK OR FLOATING CINDER CAN **IGNITE IT.** ONE MINUTE I'M JOKING AROUND, **THE NEXT I'M A HUMAN TIKI TORCH.**

I often employ slapstick physical humor to get a laugh. But how far is too far?

So I faced a choice. I could stand in the inferno and possibly become Bozo the World's Most Well-Cooked Clown *(Fig. 13A)* or I could jump out of a four-story building. As I teetered on the edge of that windowsill, I wondered how in the world I had gotten into this mess. And, like so often in my life, it was the result of one of my crazy ideas.

I was sitting in my office in Hollywood and I read in the newspaper that some young big-city residents were hindering fire rescue services. I was horrified that these heroes would risk their lives to put out a fire and yet children would get in the way, or even throw rocks. The kids thought they were having fun, and didn't understand that lives hung in the balance.

154

CUTLETS AND PEAS.

Fig. 13A

"But if Bozo were a fireman, they would know better!" I shouted as I jumped to my feet. I had goose bumps as I rounded up my team and we began planning the next big adventure. A few days later, I was talking to the Fire Commissioner of New York City. I planned to visit the Big Apple in the coming weeks and thought it would be a perfect opportunity to teach children about fire safety, how to act around an emergency scene, and the bravery of the men who risked their lives to save others.

"Everyone in New York loves Bozo!" the Commissioner exclaimed. "We'd be thrilled to have you. Get here as soon as you can." I smiled as it dawned on me that people always used the word "love" when they discussed the character. And that's remained true to this day. After all these years, I still have not ever heard anyone say, "I like you, Bozo." It's always *love!* With an exclamation mark at the end.

So early one chilly morning in 1969, I showed up at Welfare Island in the East River of New York City to become a fireman. I had two cameramen and a sound man with me. I remember the chilly breeze blowing through my wig as a group of schoolchildren

155

cheered my arrival. The training facility hosted field trips from schools throughout New York City and a group of kids had been brought in to observe my performance.

"Hi, Bozo, I'm Captain Marshall and I'll be leading your training today." The captain was much smaller than I pictured a firefighter. A slight man with a mustache and long sideburns, he still almost crushed my hand when we shook.

"First thing we'll do is get you set up with all the gear." Men approached and loaded me down with equipment. They had me kick off my Bozo shoes and step into heavy galoshes-like boots. They wrapped me in a thick coat that came almost to my thighs. Someone plopped a helmet on my head. And gauntlets were slid on my hands. I felt like a toy in a cartoon, sliding down the assembly line while robots bolted on parts at a frenetic pace.

"And, finally, you need the oxygen tank and mask," Captain Marshall said. He held out the tank with one arm extended. Yet, when I took the straps in my hand, the gear immediately dropped to the ground like it was full of lead, not oxygen. His small stature hid a tremendous amount of strength. Two men had to help me strap it on my back and I almost fell over with the weight of it.

The schoolkids laughed and cheered at all this activity. Of course, I hammed it up a bit, but it really was a ridiculous sight. All these serious, brave professionals loading down Bozo with life-saving gear.

The first thing they taught me was how to use their equipment. A test fire had been ignited using some wooden crates and logs as kindling. So we rolled out a fire hose from a nearby truck.

"Now, Bozo, when we crank up this hose, you need to hang on!" Captain Marshall warned me. "This two-and-a-half-inch hose is called the 'blitz line' and we use it for outdoor applications,

usually when we need to extinguish flames from a distance. This baby will pump out so much water at such high pressure that it'll actually blow a hole in a weak brick wall."

"Well, golly, that sounds amazing," I said. "Not quite like the garden hose we play with in the yard, huh, kids?" The schoolchildren all laughed but before I could crack another joke, Captain Marshall told the men to let 'er rip and suddenly I held an angry boa constrictor in my arms.

A couple firemen were on the hose as well, but the force was so tremendous that I had to use all my strength just to keep from being thrown to the ground. Captain Marshall appeared under my ear and yelled over the roar of the water.

"Use this to control the spray!" he screamed. I pulled the horseshoe handle backward and forward to make the torrent larger or smaller. The test fire was quickly extinguished in the deluge.

Next, we marched to a tall red brick building unadorned with any sort of architectural detail. It was just a rectangle stuck in the ground. Men in fire gear raced in and out of the doorways, and through the windows I could see people rushing up the stairs.

"This is where we train for fighting fires in skyscrapers," Captain Marshall said. "One of the primary responsibilities of a fireman is to be in tiptop physical shape."

"Well, I can do that!" I said. "I work out all the time. I work at eating ice cream and playing games and I can jump more rope than anyone!" (Fig. 13B) The children laughed but Captain Marshall wasn't smiling.

"No, Bozo, this is serious. You see, in a fire, we can't use the elevators. You have to run up the steps, carrying all your gear. Now get going!"

I thought I'd do all right, but the equipment weighed probably forty-five pounds. With those oxygen tanks on my back, I felt

157

Fig. 13B

like I was running with cinder blocks on my shoulders. As I rested against the wall on the first floor, already tuckered out, the firemen all breezed past me in the hallway. Forget the flames in the building. My legs and lungs felt like they were on fire. But I'm no quitter, so I somehow managed to drag one foot in front of the other and keep moving up those steps. Finally, I made it to the top.

I walked over to a large window and waved to the children four stories below. They cheered and waved back. I took deep breaths, trying not to pass out. Luckily, the kids were too far away to hear me. I couldn't speak at all, just wheeze and gasp. So I waved my arms and made some crazy gestures to communicate with them.

Suddenly a bearded man on a rope appeared directly outside the window and stared straight into my eyes.

"We practice hauling people out of burning buildings," Captain Marshall said to me. He had appeared at my side while I struggled to comprehend the sight of a fireman in full gear hanging from the building like a spider on a thread.

"Sometimes we have to rappel down the side of a building, or simply be lowered down. A floor might be inaccessible, but we may be able to get to a higher story or even to the roof. So we can use a rope to try to rescue people. Step out of the window and he'll hold on to you."

158

Facing torrents of water from high-powered hoses and hiking stair after stair loaded down with oxygen tanks was one thing. But being burdened with forty-five pounds of equipment while clutching a fireman weighed down with another forty-five pounds of equipment who was dangling in the breeze on a rope tied to the roof was crazy.

"We do this all the time," Captain Marshall shouted. "Go ahead!"

He pushed me from behind and I almost fell out of the window. The kids on the ground laughed and cheered, thinking this was part of the show. I bumped into the fireman on the rope and he swung out from the building.

"Come on, Bozo!" he yelled at me. "You're gonna kill us both."

"That's what I'm trying to avoid!" I shouted.

But Captain Marshall gave another shove and the fireman latched on and yanked me out of the window. We circled in the breeze and I tried not to get dizzy. I kicked in the air, as if I could get some traction, then struggled to improve my grip on the fireman. One slip and it would be Bozo scramble all over the concrete below.

And then we started ascending.

Firemen on the roof hauled us up and I clambered over the edge. I lay on the roof panting and trying to catch my breath. I was exhausted and felt like I weighed three hundred pounds with all the equipment pulling at my body. I took off my helmet and laid it on the ground.

"You guys are crazy," I said. "I can't believe you do this every day."

"You're just getting started," someone said. The building was teeming with firemen. They kept popping up everywhere I looked, pushing me to do something else life threatening. "Go down the back stairs," a thickset fireman said. He pointed me to the far side

of the building and a heavy metal door. My galoshes slapped at the gravel on the roof as I staggered forward and wondered if I really, truly wanted to see what was behind Door #1.

The corroded metal door was warm as I struggled to move it. Eventually, I managed to pull it back. Heat blasted me in the face as if I had just opened an oven door.

"Go on!" the firemen on the roof shouted at me. "The Captain is waiting on you."

At this point, I had no idea what further dangers I might face. But the kids were on the ground screaming, the film crew was following me around, and I had already dangled from a rope several stories off the ground. I couldn't turn back now.

I stepped through the door and struggled to take a breath as the air itself seemed to burn around me. Everywhere I looked, I saw raging flames. The metal door slammed behind me and the flames whooshed with the in-rush of air. Captain Marshall calmly stepped through the smoke toward me.

"This is the final test, Bozo," he said. "We ignite a portion of the building so our guys can practice working in an engulfed environment. Let's walk over that way." He pointed to an open window through which blue sky gleamed, so fresh and inviting, a square of open air in the midst of an inferno. Men rushed this way and that, spraying hoses on collapsing walls, dodging falling beams.

The captain led me to the window and I leaned out, desperate for fresh air. I filled my lungs as children cheered from below. I looked down and saw a huge cushion, like a pillow from a couch the size of a city block.

"When all else fails, sometimes you just gotta jump," Captain Marshall told me. "Sometimes we can't reach people with a ladder or a rope. So we use the inflatable cushion to catch them when they

160

jump to safety from a burning building. It's just like the stuntmen use in Hollywood."

I had to draw the line somewhere. This was ridiculous. More likely, it would be a plummet to my death.

"You gotta go, Bozo!" Captain Marshall said. "It's time. It's getting too hot in here. We have to evacuate. This is how we do it."

No way. Forget it. No how. I may have braved cannibals and vomit comets. But I wasn't going out that window.

Firemen congregated around us, pushing toward the fresh air and cool breeze.

"Dammit, Bozo!" the captain yelled. "This is for real. You're endangering my men. We have to get out of here!"

The children laughed and pointed, the camera crew panned up the building to catch me in the window frame, and the firemen wanted out. So I had a choice. I could jump or stand there and take a chance on the flames setting my wig ablaze. I couldn't back down from this challenge. Like so many of my other adventures, I had gotten into dangerous situations and always managed to come out okay. I just had to believe I'd pull through this one. I was here to teach the children, not to scar them—and me—for life.

I leaned far out of the window frame. The wind blew my wig and the air was chilly and so pure that it hurt my lungs. But it was amazing to be free of the heat, flames, and smoke. I looked down at the cushion and contemplated my chances. And then calm came over me, and I simply leaned out of the window and tumbled into the open air.

Like on the initial fall of a roller coaster, my stomach dropped. Then suddenly I heard a roaring *poooofff!* as the cushion absorbed my impact and I rolled off it and onto the hard concrete ground.

The children cheered and rushed to my side. I led them away from the massive cushion as the firemen started jumping to safety.

"Kids, those are the kinds of risks firemen take each and every day to keep you and me safe," I said. And they listened. Swept up in their rapt attention, I forgot about the heavy equipment and my aching legs and my burning lungs and my churning stomach. It was just the kids and their old pal Bozo, discussing the lives and work of firemen, and how we should respect and appreciate them.

Sometimes it takes a Bozo to help children relate to a hero.

Larry Harmon as Bozo with the New York City Fire Department

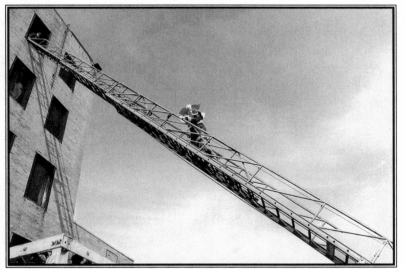

Larry Harmon as Bozo with the New York City Fire Department

"Topside, this is Red Diver Clown."

BOZO

AND THE U.S. NAVY

IN DAVY JONES' LOCKER

Q: WHAT'S RED, WHITE, AND BLUE AND GOES **BOOM?**
A: YOUR OLD PAL **BOZO THE CLOWN** UNDER THOUSANDS OF POUNDS **OF PRESSURE** AND MILLIONS OF GALLONS OF WATER.

NOWADAYS, YOU HAVE ALL THESE REALITY SHOWS WHERE SOMEONE PUTS HIMSELF IN DANGER *FOR THE SAKE OF TELEVISION.* BUT THAT DIDN'T EXIST BACK IN THE SIXTIES. EVERY TIME I WOULD GET ONE OF MY **CRAZY IDEAS,** MY STAFF WOULD BEG ME NOT TO MOVE FORWARD WITH IT. **"YOU'RE GONNA KILL YOURSELF!"** BUT I JUST HAD TO TRY NEW THINGS, **TO EXPERIENCE LIFE,** AND TO SEE HOW FAR MY **WIT,** MY **HUMOR,** MY **AMBITION,** AND MY **ABILITY TO RELATE** **COULD TAKE ME.**

THE MAN BEHIND THE NOSE

Beyond the opportunity to challenge myself with these stunts, I realized that Bozo was so famous now that he could make the transition from TV to film. So I began compiling the short educational films of my adventures into a series to expose children to all the wonderful opportunities in this great country and inspire them to pursue their dreams.

And since I had now experienced earth in New Guinea, air at the Wright-Patterson Air Force Base, and fire in New York, it only made sense that my next adventure would take place in the one element I hadn't taught children about yet: water.

A little boy in Lincoln, Nebraska, might have never even laid eyes on the ocean. He might not have any clue what a deep-sea diver is. But if he saw Bozo the Clown putting on a helmet and dropping below the waves, he might be inspired to pursue a whole new career.

But I didn't want to teach them just about any old deep-sea divers. I wanted to tell them about the divers who were heroes: Navy frogmen had played a pivotal role in the protection of our nation's waters as well as in other areas of the war effort. According to some experts, Navy divers at Pearl Harbor spent 16,000 hours underwater performing 4,000 dives on salvage missions and trying to retrieve the bodies of those brave men who'd perished there.

So just a few weeks after I told my exasperated staff my idea, I was at the Naval School of Diving and Salvage being pushed, prodded, tied, and clamped into a weird contraption that reminded me of a knight's armor.

First came a thick beige jumpsuit made of canvas and rubber. I climbed into it and my costume sleeves bunched up in the watertight arms of the diving suit. They zipped me up in the back and told me to sit down.

"Take off your shoes, Bozo," said a dark-haired diver named Romano. "Then lift your feet so we can put these boots on you."

167

He clunked down a pair of leather boots that looked like something Frankenstein's monster would stomp around in. The boots had lead plates in the soles and brass caps over the toes.

"Wowie kazowie!" I said. "How much do those things weigh?"

"They're about twenty pounds apiece," Romano replied.

"And I thought *my* shoes were cumbersome!"

Then they started clamping on the various segments of the neckpiece that would connect to my helmet. They screwed in bolts, attached seals, and tapped on the metal like auto mechanics.

"You going to check the oil under there, boys?" I asked. "How about topping off my wiper fluid while you're at it."

They didn't answer. They were too busy raising a fishbowl over my head. The MK V Helmet was made of metal with brass fixtures, and I felt my Bozo wig press down as the heavy piece of equipment rested on my shoulders. They screwed the helmet on and connected it to my suit. I was completely shut off from fresh air. I started feeling very claustrophobic, but I couldn't show the kids. I had to make it seem fun.

"Yep, Bozo, that's me!" I said as I stood up. "And diver I soon will be."

"Not yet, Bozo," Romano replied. "You still have to put on the weight belt."

Two men staggered toward me carrying a belt with straps designed to crisscross over my shoulders.

"And just how much does that thing weigh?" I cried. It was becoming a common question on that November morning.

"About eighty-four pounds," he said.

"So, gentlemen, let me ask you this: When I stand up, *if* I can stand up, how much equipment will I have on my body?"

"All total? About a hundred and eighty-five pounds," Romano said.

Two Navy men grabbed me under my arms and hoisted me up. Romano came over with a bag in his hand.

"Here are your tools, Bozo," he said as he handed me the sack, which contained an underwater blowtorch and other devices the crew had shown me how to use in the preceding days. "When you get down there to the wreckage, use this gear. Just like we taught you. Remember, your goal is to cut an entryway into the ship so we can get our heavy equipment in there to pump it out. There's already a hole, but you have to make it more accessible."

I lumbered to the edge of the deck and stood there tentatively, looking into the cloudy, scary waters of the Potomac. I knew I was surrounded by professionals. I knew they would do everything they could to save me. But I also knew I had signed the biggest stack of liability release forms I'd ever seen. In spite of the Navy men's presence, this was still a dangerous task for a novice like me.

"Off you go, Bozo!" Romano yelled.

I tried to lift my foot, but between the weight of the boots and the quivering of the nerves in my stomach, I couldn't do it. So instead of jumping, I shuffled my feet forward and tipped myself into the icy waters below.

Once I hit the river, my lead shoes and the weight belt pulled me down as if there were a powerful magnet on the sea floor. The heavy boots threatened to pull my legs out of my hips as I descended. So this is how gangsters with concrete shoes must feel.

My main concern was simply to keep myself upright. Those old deep-sea diving outfits kept pant legs sealed tight. That was because if your legs inflated with air, you could balloon upside down and float to the surface. Or even worse, depending on the type of breathing mechanism you wore, your helmet could fill up with water and drown if you turned upside down. Although the suit was engineered to protect me, I still had to keep my wits because accidents do happen. I began to worry I was going to blow up like a huge firecracker on the Fourth of July.

Though I couldn't actually get wet because the diving suit completely protected me, the cold of the Potomac still managed to penetrate and chill my bones. I touched the bottom of the river and continued to sink into the silt and dirt another few inches. Out of the corner of my eye, I saw Rob, my cameraman, capturing the footage we would use for the educational film. I was nervous, in awe of the fact that I was so far underwater yet completely dry, and overwhelmed with both excitement and fright. Rob waved to me to start acting for the cameras.

"Topside, this is Red Diver Clown," I said aloud in the fishbowl of my diving helmet. "Topside, can you read me? I have reached the bottom, over."

"Red Diver Clown, this is Topside; we read you, over." Romano's voice sounded metallic and tinny through the speakers in my helmet. "Look for hole in hull, over."

"Topside, I read you. I'll look for hole in skull. Oops! I mean, hole in hull." At this point, I was beginning to think I might have a hole in my own head after getting myself into another ridiculous situation that I might not be able to get out of. Or in this case, up from.

I turned around to get my bearings. Because of the way the diving helmet connected to my suit, I had to turn my whole body in order to get any idea of where I was. I completed a 180 degree turn and saw a dark shape in the distance.

Thinking back to reading books like *Treasure Island* as a child, I recalled sunken pirate ships conjuring feelings of adventure, boundless possibilities, romance, and excitement in me. I thought about exploring the ships, finding treasure, saving a damsel in distress *(Fig. 14A)* or two, and discovering a gleaming golden sword.

What lay in front of me had none of that.

Instead, I saw a twisted hulk of metal perched precariously on its side. The World War II gunboat seemed to have sunk at an

Fig. 14A

angle, so it was driven into the seabed like a shovel speared into dirt. Twisted, rusting metal was everywhere; the command tower was dented and collapsed; and the whole thing looked like a construction site had been dumped at the bottom of the river.

I walked toward it and felt a heavy sense of dread. At that moment, I felt very much alone.

Fortunately, the hole in the hull was easy to find.

"Topside, this is Red Diver Clown. I have located the hole and will start welding, over."

"Fire away, Red Diver Clown," Romano replied. "Remember to be careful with the point of your torch. And be sure to cut proper lines. If it's jagged, our gear will get caught and the whole operation will fail, over and out."

With the blowtorch in my hand, I paused for a moment and soaked in my surroundings. I suddenly realized I was no longer afraid. I would survive this adventure and have an informative and entertaining educational movie to show for it. And I was experiencing something very few people ever do. I was underwater, in a diving helmet like a fishbowl, about to use fire to raise a sunken ship. On my last adventure, I had been taught that water extinguished fires.

Although I went through all those trips in zero gravity, the Bozo mission never made it to space. But as I stood underwater, it dawned on me that although the experiences of being in space and underwater feel different, the dangers are very much the same. Both the astronaut and the diver toil in foreign environments in-

capable of supporting human life. They both depend on external sources of oxygen to survive; they both face danger every time they go to work; they're both surrounded by bulky costumes that hinder movement but protect life; and they're both surrounded by a sense of total silence and, after the fear subsides, calm. By going four hundred feet underwater, I had achieved, in a way, my dream of going into space.

I confidently lit my blowtorch and went to work.

"Topside, this is Red Diver Clown. The cuts look good. Entry-way finished. Welding complete. I'm coming up, over."

Rob gave me the thumbs up and I waved to his camera as I shrugged out of the torturous weight belt so I could ascend. I had enjoyed my time under the waves, but now I wanted fresh air.

I started rising to the surface, looking up as much as possible in the helmet. The water became slightly warmer and brighter as I rose. I looked forward to breathing real air, hearing a real voice, and walking around with ease. After this experience, my Bozo shoes would feel like ballet slippers *(Fig. 14B)*.

Fig. 14B

I broke the surface and bobbed in the waves like a buoy. Two Navy men reached down the ladder and helped me climb up onto the deck. They led me to a bench and I collapsed. Suddenly, back on the surface, with the normal rules of gravity in effect, I felt like I weighed a thousand pounds.

The men started working on the clamps surrounding my hel-met. They then turned the helmet to the left (lefty loosey, righty tighty) and unscrewed the bowl like a cap on a ketchup bottle.

Fresh air whooshed in as they broke the seal and I sucked in the chilly breeze just as gratefully as I had inhaled the air after being in the oxygen-deprivation tube at the Air Force base.

"You did it, Bozo!" Romano said. I smiled at him as I gulped in more air. All I could think was, "Bozo's back with a capital B!" I could see again; I could breathe again; I could move freely; I could speak to people face-to-face instead of through a tinny microphone. I could even get a drink of water if I wanted.

After the men took off the boots and equipment, I pranced around the deck, freed of all that weight, feeling as though I could leap like a gazelle.

The Navy men turned on several loud pumps and the machine began raising the sunken gunboat. They did this repeatedly in order to train the men who travel the globe and perform dangerous underwater operations just like this one. As we stood there, listening to the *chug-chug-chug* of the pumps, the clouds moved away and the sun broke through. Eventually, I saw the flagpole on top of the ship's control tower break the surface of the waves. The breeze rustled my wig; I took as deep a breath as my lungs could contain, and I wondered where my next adventure would lead me.

Larry Harmon as Bozo in diver suit

"I hadn't seen anything take a bite that big since my agent got a hold of my last paycheck."

BOZO

and the PUGNACIOUS

PYTHON IN

THE

BIG SQUEEZE

WHEN I ORIGINALLY THOUGHT ABOUT EXPANDING **THE BOZO SHOW** TO ASIA, PEOPLE THOUGHT I WAS CRAZY. AS USUAL, FOLKS TOLD ME **IT COULDN'T BE DONE,** THAT THE CULTURAL AND LANGUAGE BARRIERS WERE **IMPOSSIBLE TO OVERCOME.** BUT THANKS TO MY EXPERIENCE **IN NEW GUINEA, I KNEW THE TRUTH.**

"Name me a place on this planet," I told a doubting banker friend over lunch at the Brown Derby in Hollywood. "Some place that is as different from our country as can be."

"Laos," he replied.

"Okay, Laos it is. Now, I don't know about the television situation in that Asian country. So I'll concede a point there. But let me ask you this: Are there children in Laos?"

"Yes, I assume so."

"And do you suppose that those children like to laugh and play?"

"Well, sure."

"And do you suppose that parents in Laos love their children?" I continued.

"I'm sure they do."

"Then the people will love Bozo! He's all about love and laughter. Why would you think that's limited to American culture?"

My friend had a gray beard and wore wire-rimmed glasses. He took off the spectacles and wiped them with a napkin. "I don't know, Larry. It just seems like there must be a limit; not everything is universal."

"Love and laughter are!" My voice got a little too loud and people from nearby tables stared at me. But I didn't care.

"Listen, this thing—Bozo—*is* universal! Doesn't matter what color you are, what country you're from, what language or dialect you speak. Bozo makes people laugh and everyone needs to do that."

"I guess—"

"Everyone laughs in the same language! So nothing else matters."

By that point, my predictions weren't empty bluster. Bozomania was sweeping the globe. By the time I was done spreading the gospel of laughter, love, and big red noses, Bozo was on in more than two hundred television markets across the world. We had shows as far-flung as Mexico, Australia, Greece, and Brazil. And while I never made it to Laos to prove my banker friend wrong, I did manage to get a show on the air in neighboring Thailand.

And that's where I met a very irritable python.

My contacts at the local television station had set up a brief show at a nearby facility that was sort of a public park mixed with a rudimentary zoo. Whenever I travel, I like to explore, so I told the gang I would meet them there and I hit the streets of Bangkok. It was such an exotic city, with amazing architecture, beautiful temples, and so much hustle and bustle that no one seemed shocked by my Bozo costume as I walked down the street. Sure, folks looked and pointed to their friends, but it was a smaller commotion than it would be walking down Fifth Avenue in New York City. Every so often, however, small children would tug on the red sash around my waist and I would smile, kneel down, and maybe do a magic trick or two.

When I reached a marketplace, I thought I'd be able to walk straight through to the other side and make it to the park just in time for my show. But, instead, I got lost, confused by the maze of vendor stalls, smells, and sounds. Worried I'd be late, I started running up and down the aisles, trying to get out. But every lane

opened into another row of stalls. I tried to ask for help, but I couldn't find anyone who spoke English. And I was having trouble pantomiming the word "park."

In all these years, going all the way back to the *Commander Comet* days, I never missed an appearance. I was never even late. And now, just when I was supposed to introduce myself to a brand new country, I was hopelessly, helplessly lost.

I ran past some men butchering a pile of birds and turned to the left. My shoes slapped on the concrete as I raced up the aisle. I came to a dead end but could see through a small slit in a canvas tarp behind a stall filled with huge stacks of red peppers. I could see a street and car tires passing by. This was my chance.

I hurdled a woven container overflowing with peppers and squeezed through the opening in the canvas. I looked up the street, saw the green trees of the park, and hustled to the event.

When I arrived, some local entertainers were dancing on a small concrete platform. Children and families sat on the steps going up a small incline, like at an amphitheater.

After the dancers finished their act, a man in a short-sleeved, button-down shirt got on stage and spoke loudly. He pointed to me and made grand gestures. A lady from the local TV station explained that he was introducing me. When he finished speaking, the audience clapped and someone pushed me in the back to go onstage.

"Howdy, it's your old pal Bozo!" I said to the children. I had no idea how many of them understood English and I sure didn't speak much Thai, but I had to communicate with them in some way. So I just poured all I could into the tone of my voice and my facial expressions. As I stood onstage, I could smell a barbecue—not like the burgers and hotdogs at home, but definitely something delicious cooking over an open flame. Families and groups of people were spread throughout the park, and I figured they must have been having some sort of Thai cookout.

I started clapping my hands, tapping my feet, and bobbing my head to get a rhythm going. The audience slowly started to follow along. Someone from the station realized I wanted music and blared a tune over the sound system. I did the Bozo dance and twirled around. Some of the children danced along in the aisles.

The music kept playing and I started juggling three red balls, then four, then five. After a few minutes, I handed them to the kids and picked up a baton I had onstage. I twirled the baton and high-stepped it like in my old drum major days, punctuating the beat of the music with my steps.

And then I noticed that I couldn't smell the cookout anymore. All I could smell was something foul and dirty and rotten *(Fig. 15A)*.

Fig. 15A

The music stopped abruptly and I was frozen onstage with one foot in the air and my arm pointing toward the blue sky above.

The emcee ran up and started speaking to the audience. I tried to go along with it and casually moved offstage. The woman from the station told me that he was talking about the nearby zoo and all the amazing creatures they had. He said they had a surprise visitor from the zoo to show the audience. The children clapped and seemed into it.

Then I caught that awful smell again.

Two beefy men began pushing a big box, like an old-fashioned steam trunk on wheels, into the middle of the stage. The lid on the box was open, and I realized it was the source of that stench.

The emcee motioned for me to return to the stage, so I bounded out and waved to the crowd. Then he pointed, the crowd cheered, and I peered into the darkness of the box.

Inside was the biggest snake I had ever seen in my life. This massive brownish reptile seemed like something from a Tarzan book or possibly the Jurassic era. The two handlers reached in and pulled the snake out, like you would untangle an unruly hose. Except this hose probably weighed a hundred pounds. When they stretched the creature out, it must have been twelve feet long. One of the handlers wrapped the snake over his shoulders like a socialite throwing on a feather boa before going to the opera.

I looked at the audience, expecting the kids to flee in horror. But they smiled and clapped. Maybe those children were more accustomed to snakes than American kids were. If I whipped out a giant serpent during a *Bozo Show* in America, there would be a stampede to the exits *(Fig. 15B)*.

Fig. 15B

Suddenly, the handler dropped the python on my shoulders. As I staggered under the weight of the beast and scrunched up my face at the smell, the kids laughed even louder. They seemed to think I was playing around.

Later, experts told me that pythons don't really have a smell, unless they're kept in unclean conditions. I had heard good things about the zoo, and figured the animals were well cared for, so perhaps the transport box was foul.

In spite of my revulsion, I had an obligation to put on a good show. So I grinned larger and said, "Well, wowie kazowie! It's time for the python marathon!" And I jogged—or at least went through the motions of jogging, given that I felt like a pony carrying an

overweight jockey—around the stage with the snake stretched over my shoulders. Every now and then, I'd put a little hitch in my step or fake a bit of clumsiness to make the kids laugh.

Eventually, the emcee started talking again. I went to the corner of the stage to ask my interpreter what to do. To my surprise, she didn't recoil or react in any way when I came over with the snake. She instructed me to stand by the emcee while he told the crowd about *The Bozo Show*.

I made my way to the emcee's side, and waited obediently a couple steps behind him as he spoke. The snake remained draped around my shoulders, with its head and tail lying on the ground.

Suddenly, my collar began to jiggle, and I noticed that the python was moving. He was sliding down to my left and gently wrapping around my waist. I looked to the handlers for help, but they were gone.

As the emcee continued, the snake wound around my waist a couple more times. His body was so thick that my torso was wrapped tighter than an ancient mummy in a pyramid.

How much longer was the emcee going to talk? I looked over to the interpreter, but she was smoking a cigarette and staring out at the expanse of the park.

And then I felt it.

It was like a belt being cinched at first. Just one notch. Nothing to get concerned about.

The crowd erupted into applause and the emcee smiled broadly.

What was that man saying?

And then it happened again. This time it wasn't like a belt. Instead, it was like a suit of armor that was six sizes too small. The pressure was tremendous.

I waved and said, "Hey!"

The audience laughed. The emcee turned to look at me. Then he smiled, gave me the thumbs up, and went right back to his speech.

The python cinched tighter and I staggered back with the force. The crowd's laughter increased.

"Help!" I tried to scream. But nothing came out, because nothing was coming in. I couldn't fill my lungs with enough air to make a peep. I frantically waved my arms up and down, but the crowd just laughed. They seemed to think I was imitating a bird or something.

The emcee continued blabbering.

So this was it, boys and girls. It was lights out for old Bozo any moment now. Underneath that white makeup, my face was turning blue from the pressure.

The snake started coiling farther down my body, like gears rotating in an intricate machine. Soon, he was wrapped around my left leg and his head was near my shoe. Meanwhile, the rest of his body remained around my torso where it continued to choke the daylights out of me. I felt light-headed and began to worry that I was going to pass out. I wondered if I would be able to sit down with this creature wrapped around me.

I figured my clown clones would be able to continue the shows back home. And maybe the legend of Bozo would spread throughout Thailand, and I'd be known as the entertainer who died on stage, choked by an impolite python.

The snake's head began poking around down near my left shoe. Without really thinking, I slid my right foot near his head and put the tip of my shoe beside his mouth. As the snake opened up his mouth, I could see his jaws unhinge. He was going to swallow me whole!

His jaws continued opening and opening and opening. I hadn't seen anything take a bite that big since my agent got a hold of my last paycheck.

He cinched tighter around my torso once more, like he was tensing up for power or leverage or something to make a final push. And then he threw his jaw open even wider, determined to fit me down his gullet.

But he couldn't get his mouth around my feet. My size 83-AAA Bozo shoes are like giant diving flippers—narrow in the back, wide and floppy in the front. That's one of the best things about the costume: I don't ever have to worry about putting my foot in my mouth. Even that voracious jungle creature couldn't get his chops around a Bozo shoe.

The snake suddenly loosened up and slid down my body. I sucked in a huge breath of air and felt my chest expand. The python seemed defeated. It curled up sadly on the stage floor.

Just then, the emcee finally finished. He waved and walked off the stage as the children clapped. The handlers returned from wherever they had disappeared to and started gathering the snake. The interpreter dropped her cigarette and came to the side of the stage.

I gasped and rubbed my chest.

"Did you see that?" I yelled at the interpreter.

"Yes, Mr. Bozo. You were very amusing."

"Amusing? That thing almost killed me!"

"Yes, you killed the audience with laughter. They loved it."

"No! Not them. Me! It almost killed me."

"Yes, you. You are very funny entertainer."

Instead of directing me back to my hotel, she started walking away. So I decided to find my way back myself and promptly got lost in the marketplace again, but this time I was happy to be alive and to enjoy all the amazing treasures and exotic foods there.

In the Bozo cartoons I created, my character interacted with a circus lion or two—even a kangaroo that my illustrated self tried to teach to box. In live events, I had performed with horses, dogs, and even elephants. That day in the Bangkok marketplace, after my life and death encounter with the pugnacious python, I made a vow to work only with mammals. Snakes tend to squeeze all the life out of the stage.

PART III · The Big Leagues

"Juuust a bit outside."

BOZO

AND THE CLEVELAND INDIANS

IN A CLOWN ON THE MOUND

AS A CHILD, I WOULD NEVER HAVE DREAMED THAT I'D BE ON THAT PITCHER'S MOUND.

I had grown up listening to Cleveland Indians games on the radio with my father. Occasionally, we'd go to the ballpark and catch an afternoon game. We'd sit way up in the bleachers and watch Bob Feller *(Fig. 16A)*, nicknamed the Heater from Van Meter, throw that baseball at over a hundred miles an hour.

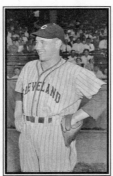

Fig. 16A

My father had died of heart problems years earlier in Los Angeles, where we had the jewelry shop with Mom. Whenever I think of him, his incredible work ethic, and his love of Cleveland sports teams are the first things that pop into my mind.

So I was excited when my publicist said there was an opportunity to throw out the first pitch at a Cleveland Indians game. I

had made a stop at a Toledo hospital to visit sick children, where I'd met a little girl named Jenny. She was three years old and had never left the hospital grounds her entire life. Everyone on her floor said she wouldn't talk and never smiled.

I eased into her room and quietly kneeled by the bed. With my costume on, I must have looked bigger than life to her, so I tried to get on Jenny's level and carefully interact with her in a manner she would find comfortable. I swept her blond hair out of her eyes and took her hand. I told her a joke in the Bozo voice and laughed, but quietly—not booming with chuckles as I would normally do. And Jenny looked at me and smiled. The nurse in the room called for people down the hall. It was the first time they had ever seen the little girl light up like that.

The experience with Jenny would have made for a great day in and of itself. But when I left the hospital and was told I could throw out the first pitch at an Indians versus the Detroit Tigers game, that was just the cherry on top of a giant ice-cream sundae.

I immediately accepted and made plans to head to Cleveland. On the way, I decided to practice a bit by throwing the staff a few curveballs of my own.

"Jerry, here's the thing," I told my publicist. "I don't want to just toss out one ball. I really want to pitch. And you gotta give me at least three pitches."

"Well, I guess we can get the Indians folks to allow that," he said.

"And I want to face a real batter!"

"Uh, well, okay. I don't know about the liability and things like that, but I'll see what I can do." Jerry was a respected Hollywood publicist and his firm had represented movie stars, rock musicians, and Las Vegas casinos. He had fielded all kinds of requests from celebrities over the years, so when I said I wanted to get a batter at home plate, he just sighed and picked up the phone.

189

The bus finally pulled up to Cleveland Stadium *(Fig. 16B)* and I stepped off in full Bozo regalia. Jerry and our team shook hands with the folks from the Indians offices and they led me into the massive structure. We stepped into a long, dark concrete tunnel and I could see light and the green grass of the field at the end.

Fig. 16B

I'd seen the field as a fan with my father so many times as a child, but I never imagined I'd actually be standing on it as part of the game. I thought about all those boys and girls sitting there in the audience just like I once did, and I wanted to give them the encouragement to know that one day, if they worked hard enough, they could be doing fantastic, wonderful things that maybe they didn't even dare to dream because they didn't yet have the belief in themselves, because nobody had told them they could. That's always been one of my goals with Bozo: to tell kids, both the young ones and the older ones in their forties and fifties, that they can.

As we emerged from the tunnel, I heard the crowd roar. In all my years of performing, I never—and will never—get accustomed to that sound. It's so loud that you feel it everywhere from the tips of your hair to the ends of your toes. Many of the other men who portrayed Bozo all over the globe also talk about this. When Bozo steps onstage, he's met with a massive wave of applause and emotion that's so powerful it almost knocks him down. I've been to Hawaii, and seen those thirty- and forty-foot waves on the North

Shore. And they're nothing but a ripple in a bathtub compared to the deluge of love that pours down when Bozo's around.

As I waved to the crowd, a few players from both teams came up to say hello, followed by a couple stadium people.

"Now, Bozo, you can go out there and stand wherever you'd like to toss out the first pitch," said a man from the stadium. "Some folks go just to the dirt a few feet short of where the pitcher actually stands. Others go about halfway. Just go to wherever you feel comfortable."

"I want to stand on the rubber. Just like the real pitchers."

"Okay, that will be fine."

A beefy guy with a mustache in a Tigers uniform approached. As he shook my hand, he told me that he had actually gone to a taping of *The Bozo Show* in his hometown. "You'll be pitching to me today. I can't wait to tell my kids about this. Everybody loves Bozo!" The Tiger leaned a bat against his shoulder and walked toward home plate.

Jerry told me it was time to go, so I strolled out to the mound and the crowd went nuts, stomping its feet and screaming, "Bohhh-Zo! Bohhh-Zo! Bohhh-Zo!"

Once I got near the mound, I realized the distance to home plate looks a lot longer than it does on television, or even from the stands. I knew the official distance was sixty feet and six inches, but, in that moment, it looked farther than from Los Angeles to San Francisco. The last thing I wanted to do was not be able to get the ball to the catcher. I also didn't want to toss some sissy throw, lofted way up in the air, so the catcher had to run under it like a football player returning a punt. No way, no how. I had to make a good pitch in front of all those people. I had to show them that Bozo knew how to throw.

Just then, the wind picked up and I felt it blowing through my wig. It grew darker in the stadium. Over the stands, the sky began to boil with black and gray clouds. As I felt the seams of the baseball

in my hand, a couple raindrops hit my face. And, in that moment, I realized something: I had no idea what to do!

The crowd was cheering and the batter was waiting and the storm was coming, and your old pal Bozo was frozen on the mound.

Back in the thirties, there was a comedian named Joe E. Brown who played a little baseball prior to making movies. He had this huge wide-open grin, like a python trying to swallow a giant shoe. An advertisement for one of his movies actually described Joe as "the man with the wide-open face." In the baseball films he did, he'd go through these crazy wind-ups before pitching the ball. So I decided to pull a Joe E. Brown.

I wound up with my right hand. Then I wound up with my left hand. And then I wound up with both hands. I threw my giant shoes up in the air until they blocked my entire view of home plate and the pitcher. And, finally, I reared back and let that sucker go.

The crowd cheered and the batter was laughing so hard that he swung and missed. So that was one down; two more pitches to go.

The catcher tossed the ball back and I composed myself, looking all serious like a pro pitcher. I held the ball close to my chest and stared at the catcher. I shook off a couple signs, waving my head from side to side vigorously. Then I contorted myself, spun my arms through a few gyrations and let the ball fly.

The catcher leaned over to the left and caught it, and in my head, I imagined the announcer saying, "Juuust a bit outside."

The rain started trickling down faster. I could see the batter digging in his cleats. He had been playing along with the gag, enjoying the act and entertaining the crowd. But suddenly, I saw his eyes squint. On previous attempts, he'd stood there casually holding his bat. But now he was choking up on it. The bat was waving in the air, making small circles as the batter tensed up for his swing. For the first time, I noticed the bulging muscles in his forearms and shoulders.

Then I remembered all the stories about pitchers getting nailed by line drives to the head. In just a matter of one or two seconds, a batter can pummel a shot back at the pitcher that can send him to the hospital *(Fig. 16C)*. And in full Bozo costume, I was an easy target. A good shot to the noggin could take my head off completely, leaving the wig fluttering in the air.

Fig. 16C

But I couldn't back out now. I leaned way, way back—so far back that the rain that had collected in the bowl of my wig dripped out. I threw my massive shoe up in the air as I coiled my body.

The crowd chanted, "Bohhh-zo! Bohhh-zo!"

And whoa Nellie, did I ever let it rip!

I hurled that ball with all the might I could muster. And through the pounding of my heart, the noise of the crowd, the drizzle of the rain, and the murk of the sky, I saw it fly straight and true. It was like slow motion: I watched the ball follow a perfectly straight line, as if it had been drawn with a ruler, until it finally dropped out of the air at the last second.

And that drop did it. Paul Bunyan chopping down trees didn't look as powerful as that batter did. He swung his bat ferociously, precisely. And he missed it completely. I got a strike!

And the crowd went wild.

The drizzle stopped as I walked off the mound. Two strikes and one ball. That's not too shabby for a clown on the mound.

The Indians went on to lose that game badly.

"The biggest mistake we made was not letting Bozo pitch the whole game," the manager told me afterward.

I relaxed as we drove out of Cleveland. I enjoyed my experience throwing the pitches, but it wasn't something I thought I'd ever do professionally—although my giant shoes would probably make scoring runs easier. I could stand on third and already be halfway home just by extending my toes.

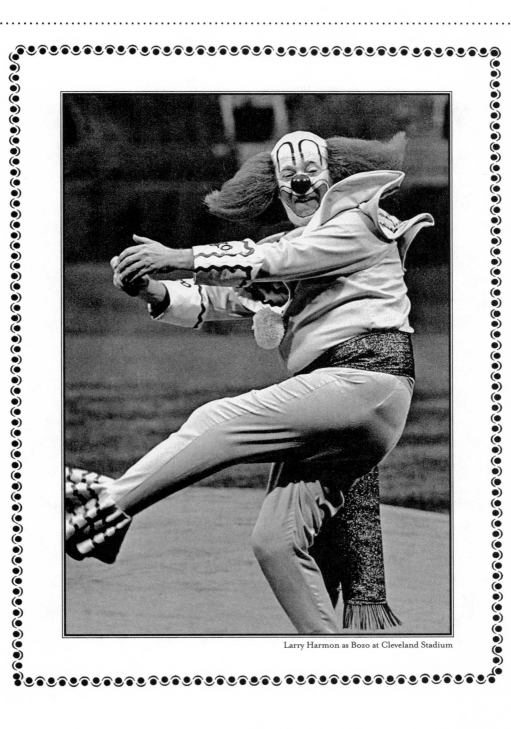

Larry Harmon as Bozo at Cleveland Stadium

A CLOWN ON THE MOUND

"Let us not ask what we can do for Bozo. Let us ask what Bozo can do for us."

SOMETIMES IN LIFE, CERTAIN **DOORS OPEN.** AND IF YOU WALK THROUGH THEM, THINGS WILL NEVER BE THE SAME.

I didn't have any illusions about this particular door. I knew I wouldn't become the President of the United States. But I did believe that I could contribute to our country in some small way. I just didn't think anyone would try to assassinate me.

I love my country for the opportunities it gave me. You can do anything in this great land. Yet, even though we have the best country in the world, many people don't want to get involved in politics. Boy, do they get excited, and swear, holler, rant, and rave about the leader of the country when they don't like something he's done. But if they want to exercise the right to holler, then they should exercise the right to vote. And not all of them do.

In 1984, horrified by low voter turnouts in recent elections, I decided to help encourage people to participate more in this great country of ours. So I talked to political folks in Washington that I knew. And they said, "Why don't you run for the presidency of the United States?"

The idea seemed preposterous. But they were insistent.

"You don't understand," they pushed. "You stand out in the country—and in the world—as Bozo. If you run for the presidency

legitimately—not as a lark, a funster, or a prank—and register as a candidate in every state and do what you have to do, you'll get a lot of people to listen."

In a way, I had been building toward political action my whole life. I recalled listening to Franklin Delano Roosevelt's fireside chats on the radio and imitating the president to entertain my family. As I developed Bozo, public service had always been important to both me and the character. And in 1963, I'd received a phone call that had made a huge impression on me.

It was late in the fall. I was in the office and my secretary, who had previously been the business manager for burlesque dancer Gypsy Rose Lee, told me I had a call on my private line. I picked up the phone and immediately heard a familiar voice.

"I'd like to speak to Bozo," the voice requested in a sharp Massachusetts accent that was famous the world over. Now you have to remember that in Hollywood at that time, there were dozens of very talented voice-over artists and actors. My pals and I always played pranks on each other, so I wasn't buying it.

"Bozo's not here at the moment," I responded, in a perfect imitation of that famous Massachusetts accent.

"It's very important that I reach Bozo," he said.

We jabbed back and forth for a bit. I played along with the prank, perfectly mimicking the speaker's voice. I gave him a hard time, refusing to tell him my name, and he laughed along with every word I said. "Well, my name's Hibber Habber, Hobber Hobber, Hubber Hummer," I quickly said, using a riff on names from my stage show.

But that last gibberish name caught his attention. And he revealed something very specific about Senator Hubert Humphrey, who would later become Lyndon Johnson's vice president. He mentioned that he had just spoken to Humphrey, who was very sick at the

199

time. I knew about Humphrey's illness because we had exchanged a few letters.

Oh my god, I've got JFK on the phone! I thought.

I apologized for thinking the call was a prank. He said I did such a good impression of him that I could give his speeches if he suffered from laryngitis. And then he said, "Do me again."

I did as instructed, and he laughed once more at my impersonation. He had a tremendous sense of humor, and as I leaned back in the chair in my Hollywood office suite and he sat in the White House, we shared many laughs.

President Kennedy told me he wanted Bozo to serve as a symbol for international safety programs. We chatted a bit about his ideas and discussed meeting after he returned to the White House from a Dallas visit he had planned.

At the end of the call, President Kennedy said everyone in the White House was a big fan, particularly his daughter Caroline. "If Caroline controlled the votes," he said, "next election, well, you'd be in the Oval Office and I'd be outside looking in!"

He finally said he wanted to change those famous lines from his inaugural address. "Let us not ask what we can do for Bozo," he proclaimed. "Let us ask what Bozo can do for us."

More than twenty years later, in 1984, I thought about that phone call often as I prepared to run for president.

Bozo is apolitical. He's not about lobbyists or special interests. He's not beholden to any party platform. He's just about fun and caring and hope—and, most of all, love and laughter. I was taking a tremendous risk with this whole campaign. I could have destroyed the icon I'd worked so hard to give to the world. But as JFK inquired many years earlier, what could Bozo do to help the country? I knew the answer: He could get young people to vote.

200

When you announce a campaign for the White House, you have to do it in the right way. It requires a certain grandeur, a certain pizzazz. You can't just do it at the local fast food joint. From my years in the entertainment business, I knew how important it was to make a splash. So I decided to announce my candidacy in Washington, DC, to prove we were taking this seriously and weren't trying to make fun of the electoral process.

Because we had to stay somewhere in Washington, and since I'm a history buff, I thought, What better place than the Watergate Hotel?

"You don't have to tell me who this is!" the Watergate's manager said on the phone as soon as I asked for a room. "My kids love you. My family loves you. I love you. Leave it all to me. You'll be well taken care of when you arrive."

I was ill when we pulled up to the Watergate, sick from the flu but keeping up appearances in full Bozo costume. Even in the best of circumstances, it's difficult to breathe wearing a big red nose, but add in congestion and I couldn't get any air at all. My voice was gone, and I had to take spoonfuls of honey just to croak a few sentences at a time. Furthermore, I was scheduled to deliver this tremendously important speech the next day, and I had only the roughest of outlines. I didn't know the details of what I would say or how I would say it.

They put me in the suite where Richard Nixon *(Fig. 17A)* used to stay. "I didn't ask for this," I said. But the manager was a fan,

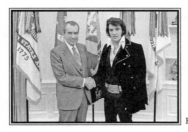

Fig. 17A

and he wouldn't hear otherwise. The suite had two bedrooms, a huge living room, and a dining room with a table that sat twelve. It was fit for a president.

Nixon had this important-looking desk that faced floor-to-ceiling windows overlooking the Potomac River. It was so cold outside that you could almost see the frost in the air. I asked everyone to leave me alone and decided to write what was in my heart.

Sitting in Nixon's chair, with my oversized red shoes jammed under his desk and the winter sun reflecting off the icy Potomac, I went to work. I had no time to change. I was still wearing my red wig, red nose, white face makeup, and blue costume. By the time I got up from Nixon's desk, it was dark, but I'd finished my announcement speech, concluding it with a tribute to John F. Kennedy's words to me decades earlier.

The next day, a woman from the press club introduced me to a host of microphones, cameras, lights, and reporters. "Ladies and gentlemen," she boomed, "the next President of the United States, Larry 'Bozo' Harmon!"

I balanced a pair of glasses on my red nose because I thought they made me look like a statesman, and made my way to the stage. In that wonderful moment, as I stepped to the podium, I had no idea of the dangers I would face on the campaign trail.

My plan was to visit every college campus I could get to in the United States—Columbia, Ohio State, Harvard, Yale, Georgia Tech—and lead big rallies. I also scheduled campaign stops in New York, Boston, Los Angeles, and many other places throughout the country, but those college rallies were most vital to my mission to register young voters.

I knew the students wouldn't turn away, because it was Bozo talking. At Columbia University in New York, the sky was dark and mean, with clouds rolling overhead. It threatened to pour any moment and I knew I had to reach the audience quickly. I had one hand

holding my wig and one hand holding the microphone. But it didn't matter. Regardless of the difficult circumstances or elements, this was still the world's most famous clown connecting with his fans.

"I'm your old pal, Bozo," I told them. "I've been in your home for most of thirty years and I've given you nothing but fun, love, laughter, help, and inspiration. And I'm here to tell you how important it is to vote!"

They ate it up. Because, you see, all you have to do is find the truth. You have to recognize the truth because it stands all by itself. And no one can deny that, even if the speaker of the truth is wearing greasepaint makeup and a painted-on grin.

I campaigned on a tour bus and it wasn't easy because most of me didn't fit. The bathroom was so small that not only were my shoes too long to rest flatly on the floor, but my wig wouldn't fit in the door. There were tons of people on that bus: photographers, reporters, assistants, family members, and eventually, the four security guards I had to add for protection.

The career politicians blocked me from getting any kind of government protection, so my detail wasn't Secret Service like the other candidates'. I had to hire and pay them myself. All my bodyguards had black belts and were licensed to handle firearms. Each one was a master in the art of protection, and I paid them to stick to me like chewing gum on the bottom of a theater seat.

One of them was about seven feet tall. He was on the Cleveland police force, a black belt in Kung Fu, and a nationally ranked expert in .45 caliber pistol marksmanship. Someone who clearly didn't know what kind of risk he was taking snuck into this giant's hotel room and stole his pants. They were far too massive for any normal-sized man to wear, but I don't know, maybe the thief needed curtains.

I nicknamed the giant "Cleveland," and he would go on to save my life. He shadowed me, babied me, and watched me like a hawk. I

203

never walked into a room alone. He always went in first and checked the closets, the bedroom, the bathroom—everywhere.

One afternoon, we were in my hotel room in Dallas when the phone rang. Cleveland answered, but the caller thought it was me on the line.

"Sooner or later, clown," the voice said, "you gotta leave your room. And when you do, I'm waiting. I'm going to kill you."

Cleveland turned to me and said, "We got trouble, right here in River City."

Now, whether it was in school or in the Army, I'd had my share of scuffles over the course of this crazy life. But when someone threatens to kill you, that's a whole new ball game.

Cleveland called the Dallas police, who quickly marched into the hotel with all these officers and detectives. They didn't know where the caller was hidden, or what type of weapon was involved, so they were visibly anxious. Because of this, prying reporters started banging on the door to see what all the fuss was about.

"You have to get out of Dallas," a policeman told me. "We'll do whatever we can to get you back on the bus so you can go to Houston."

Fig. 17B

Texas Rangers (*Fig. 17B*), city police officers, sheriff's department staff, my security folks—everyone gathered in my room, surrounding me. Next, we stormed through the door and down the hallway, every single one of us jamming into the elevator car. Reaching the ground floor, the door opened, and another big

throng of people met us there, carrying me along through the lobby like a rushing wave.

Because I was such a noticeable target, the men around me were three or four deep. Once they rushed me onto the bus, we thought everything was okay. But then I heard screaming. The police raced off the bus. Camera flashes went off in rapid fire throughout the hotel lobby. They had found my would-be assassin.

In the hotel, the payphones were on the side of the lobby closest to the elevators. And standing by one of the phones, they'd found a woman dressed all in white, with baggies covering her hands and feet. She had a gun in her purse, and was stationed there waiting for me to get off the elevator. She just hadn't expected my security entourage.

"The loon thinks you're a threat to the American people," an investigator told me later. "She heard you on the radio and thinks you're going to mess us up with the Russians."

Nothing could have been further from the truth. But in her delusions, the lady misunderstood something she'd heard me say in a radio interview. Earlier that day, I'd spoken to a bunch of Dallas radio broadcasters in the airport. "Why do you want to be president?" they wanted to know. "What are you going to do if you win?" All the big questions. Then one fella asked, "What is the first thing you want to do in the White House?"

I replied that I wanted to meet Russia's leaders. "I know they've got grandchildren," I explained. "And the first thing I want to do is go to Russia, get off the plane, and meet with the Soviet leaders and their families. It will be cold in Russia that time of year. And we'll stand there on the tarmac in bulky winter coats. Before we go to the Kremlin, before we sit down at any conference table, I want to lift up this grandchild—doesn't matter who, just a boy, who I know someone loves a great deal. The little boy will probably be bundled up against the cold and look like a big marshmallow. I want to hold

205

that little boy in my arms and ask the politicians, 'Do you want this little grandchild you love to never grow up? Never have a chance to live and enjoy this beautiful world?' If we try to improve relations with Russia, we can save our world and save our grandkids."

When we select a president, we're looking for a good story-teller. FDR, Kennedy, Reagan, Clinton—they all told great stories. So all I did was tell a good yarn about going to Russia to meet the leader there, and it darn near got me killed.

The next time someone tried to assassinate me was just a week later, at the University of California in Davis. I was onstage speaking to thousands of kids on the lawn.

"The Bozo platform is based on a very simple acronym," I told them. "For more than thirty years, whenever people ask me what Bozo stands for, I tell them he's all about P.U.L.L.: Peace, Understanding, Love, and Laughter. And the best way for me to share my ideas of peace, my understanding, my love for you all, and my laughter is to speak with you. I firmly believe that it is crucial that whoever is in the White House *hears* your voice. So every Thursday morning, you get the White House number and call your old pal Bozo. If you live in Manhattan, New York, or Paducah, Kentucky, it doesn't matter—all should have equal access to the White House. Tell me what's happening in your life. Tell me your problems; I'll do my best to help you, and we'll share a circus tent full of laughs and love."

As I was speaking, I saw a blur out of the corner of my eye. It was a kid on a bicycle. He was no older than twenty, with long black hair that would have normally hung down over his face. But he was pedaling so fast that his hair flew behind him like a racehorse's tail. He was oblivious to the kids on the lawn, to security guards, to everything. And he was racing toward me like he had been shot out a cannon.

When he was eight or nine feet away, I noticed that in his right hand, he was gripping a knife against the handlebars. Then, sud-

denly, Cleveland pounced on him, completely engulfing the kid. He lifted both him and the bicycle into the air, carried them to a police car sitting nearby, and tossed them both into the backseat as casually as if taking out the trash. I never did find out why he wanted to harm me. Clearly, peace and love weren't part of his platform.

I knew I could handle a crowd. That's been my life's work. And I knew I could do a job, no matter what it was. But the one thing I didn't count on was being assassinated for doing that job. People don't take a political office thinking that, or they wouldn't run. Abe Lincoln didn't worry about it. President Kennedy, Bobby Kennedy, none of them. Nobody wants to die. Yet many people in this world were never raised with love or taught about understanding, and some of those people grow up to become adults with fear and bad intentions in their hearts.

At one of our last stops on the campaign trail, at Miami University in Ohio, a police car escorted our bus to the side of a big stage with Bozo banners all over it. The school band struck up "God Bless America" as we stopped and I stepped out.

The mayor made a speech and then gave me the key to the city. As I waved to the crowd, my blue pants rippling in the breeze, suddenly I was raised into the air. It felt like being snatched up by the hand of God. Cleveland had grabbed me by the back of my shirt and the seat of my pants, and slung me onto the bus. He shook his fist and yelled at a group of thugs standing by the stage, then jumped on after me. The bus pitched to one side with his weight, and we screeched out of town.

"What happened?" I asked Cleveland.

"While you were waiting to accept the key to the city, those guys said, 'This is it! We got him now. Kill him!' So I took care of the situation."

Over the course of that campaign, I wasn't a member of any party, so voters had to write my name, Larry "Bozo" Harmon, on the

ballot. They wrote it hundreds of thousands of times, which was more than I'd expected, but of course not near enough to win. So I never went to Russia to speak with its leaders and make their grandchildren laugh, but I did accomplish my goal of getting more young people to vote. Hopefully, those kids went on to participate in elections for years afterward—maybe some even ran for office themselves—all because a clown called Bozo talked to them like friends when no one else did.

After my campaign, I was at a country club in Ohio. As a child, I had been to this country club and now all these years later, I was a celebrity guest at a charity event there.

After I spoke, some members of the Democratic Party approached me. "Bozo, we want you to represent our party in the next election," one guy with freckles said. "Next time around, if you join us, we are confident, just as sure as we're sitting here, that you will be President of the United States."

We discussed this plan until our drinks grew warm. But I said no. I had made my point. I had made hundreds of thousands of points. And I knew I had gotten lucky on the campaign trail. If I ever got in the White House, there would just be more people trying to kill me. So I declined. And they ended up backing Michael Dukakis, who was defeated in 1988.

Interestingly enough, my famous character continued to play a role in the nation's political history. In 1992, George H. W. Bush (*Fig. 17C*) derogatorily called Bill Clinton (*Fig. 17D*) a bozo, to which Clinton later responded: "He called us 'bozos.' Well, all I can say is, Bozo makes people laugh and Bush makes people cry. And America is going to be laughing on Tuesday."

Sure enough, Clinton won on that November Tuesday. And I still get Christmas cards from him every year.

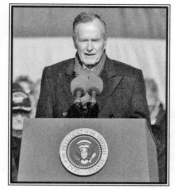

Fig. 17C

Fig. 17D

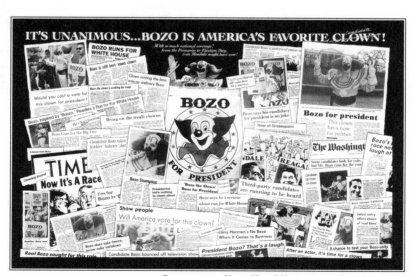

Press coverage of Larry "Bozo" Harmon's presidential campaign

THE INCREDIBLE CAMPAIGN FOR THE RED, WHITE, AND BLUE

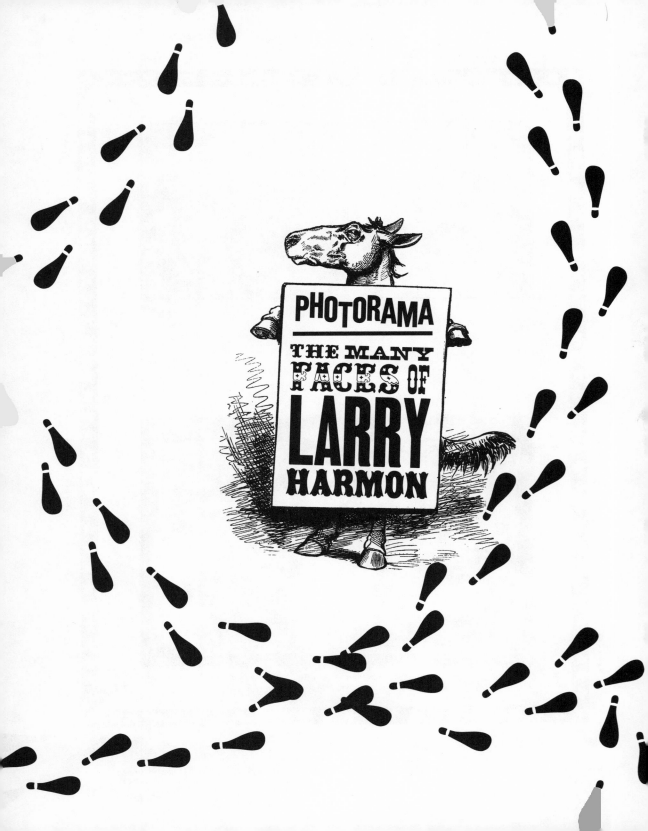

Snapshots from Larry Harmon's many film roles

Larry Harmon as Stan Laurel

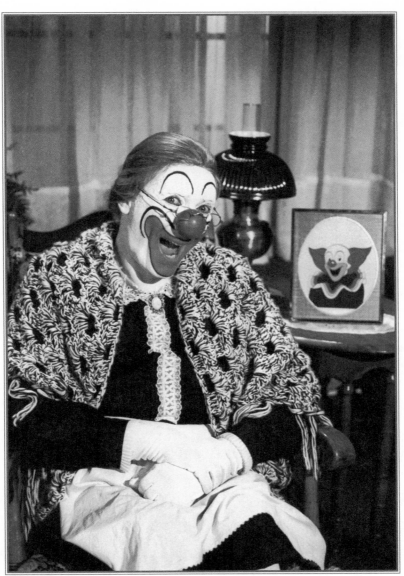

Larry Harmon as Ma Bozo

B4

Larry Harmon as Bozo on the set of *Willy Wonka & the Chocolate Factory*

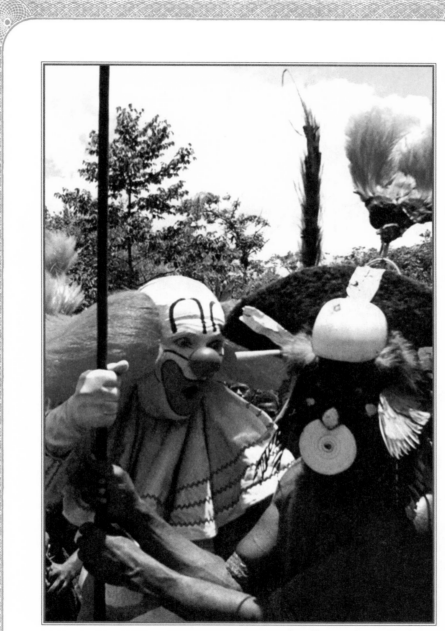

Larry Harmon as Bozo in New Guinea

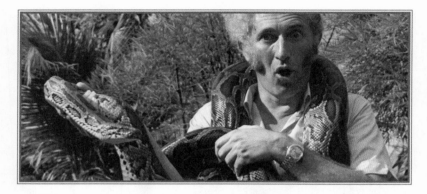

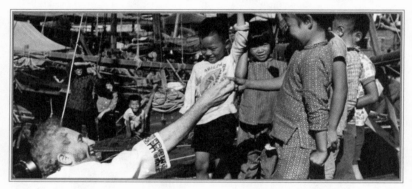

Larry Harmon in Thailand

Larry Harmon as Bozo in Paris

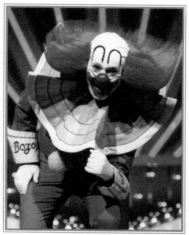

Larry Harmon as Bozo on set

Larry and Susan Harmon in South Africa

Larry Harmon
Future groom "62 going on 21"

Bozo and his Bozette to say 'I do' by a Paradise waterfall

United Press International

LOS ANGELES — There will be only two rings and no audience when Larry Harmon, known to television viewers as Bozo the Clown, marries his film company's vice president today in Honolulu.

"We're going to have a very private service, just me and her and the judge by a waterfall," Harmon said in a telephone interview. "There's hardly a thing in this world we don't do the same, and we both felt it would be more special this way."

Harmon, who originated the character of the red-headed clown in 1950, said his fiancee, Susan Breth, will assume the name Bozette after the cere-

mony.

Breth has worked for his film company for eight years.

Larry Harmon Pictures owns and produces live-action Bozo shows for cable television, cartoons of Bozo and all products bearing his image, as well Laurel and Hardy products and productions.

The company plans several offsprings for next year, including a "Bozo For President" animated special and a cartoon series in which Bozo has a family called "The Bozostuffs."

Harmon, who said he is "62 going on 21," has two children by a previous marriage. Breth has had three children.

Media coverage of Larry and Susan Harmon's nuptials in 1987

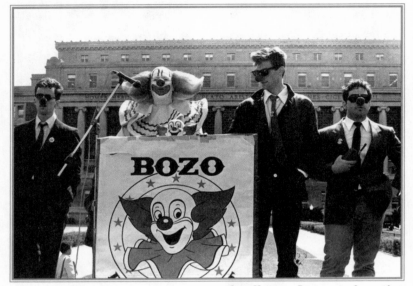

Larry Harmon as Bozo running for president

Larry Harmon as Bozo running with elephant

"The next thing I saw was Saint Peter, welcoming me into heaven."

THE LOS ANGELES
PARAMEDICS
AND THE AMOROUS
AGENT
IN A MIRACULOUS
RECOVERY

211

THE PARAMEDICS WERE SO ABSORBED WITH ALL THE BOZO MEMORABILIA ::: THAT I HAD TO SAY, "HEY, REMEMBER ME? I'M HAVING A HEART ATTACK OR SOMETHING OVER HERE!"

I didn't know what exactly was happening to me, but I was covered in a clammy, cold sweat and there was some sort of fullness causing an unbearable pain in my chest.

It seems that medical emergencies always happen at night. What is it about the quiet darkness that invites so much pain and trauma? I suppose sometimes it's a joyous emergency, like when a mother goes into labor. But far too often, it's a harrowing situation of life or death.

So it was that I suddenly found myself staring at the ceiling in the middle of the night in 1985. I couldn't catch my breath, there was incredible pain in my shoulder, and my chest felt like it would explode. I'm not one to run to the doctor for every sniffle and sneeze, so the fact that my first thought was going to the hospital indicated how serious this was.

My wife Susan called 9-1-1 and pleaded with them to hurry. As we waited for help to arrive, it seemed like hours were going by.

"What's taking them so long?" she fretted as she peered out the window, searching for flashing red lights.

I can't remember what I was thinking. My mind raced, but at the same time, I felt disjointed, sort of paralyzed with fear. My wife helped me get out of bed and get dressed for our trip to the hospital.

"Finally, they're here!" Susan said as she ran to meet the medics. I slumped in the chair, wondering what was happening to me, and if I would make it. I had been in some tough spots over the decades, but at sixty years of age, maybe it was my time to go. That seemed too young to die, but you never know when your final curtain is going to fall. My parents had both passed away as a result of heart ailments, so maybe my genes were catching up to me.

I heard a young man's voice say, "Oh wow, look at this!"

Susan said, "He's in here."

Another male voice said, "Check this out."

And then they were crowded around me. One paramedic held a stethoscope to my chest while another guy looked around the room. We had a large marble table with some figurines on it.

"Do you guys collect Bozo stuff or something?" he asked. "You've got a lot of memorabilia here."

Susan pointed to me and said, "He *is* Bozo."

"Wow, I loved that show as a kid!" the paramedic exclaimed. The other guy put the stethoscope back around his neck and looked up at an inflatable Bozo punching bag.

"Hey, I had one of those!"

"Me, too," his partner said. "My brother and I loved that thing."

"Guys, I'm down here," I said, struggling to get the words out. I don't mean to imply that the medics were being unprofessional. I was just so scared that I wanted every brain cell and every ounce of training focused on me.

I promised them I'd tell jokes and sign autographs later if they just got me through this. So they put an IV in my arm and got down to work.

I remember how slow the gurney seemed to move as the wheels sunk in the depth of our condo's carpet. Once we hit the hallway, we moved quicker. Downstairs, the paramedics loaded me into an

ambulance and one of the guys sat next to me. Susan jumped in the front seat with the driver and the siren howled as we sped down Wilshire Boulevard.

Calm came over me. The experts were here and we were on our way to the hospital. The UCLA Medical Center was only a couple miles away where even more help would be waiting. I thought everything would be okay.

"We're almost at the hospital entrance, Larry," the paramedic told me.

"It's fine," I said to myself. "Everything's going to be fine."

Until I felt like I was falling and my body was shutting down.

Think of a giant warehouse with banks of lights. You flip a switch and a portion of the space goes dark. Another switch and more darkness. The blocks of darkness add up until the entire warehouse is pitch-black. I felt like my lights were being turned off and patches of darkness were sweeping through my body.

The last thing I heard was the paramedic saying, "Oh shit."

And then everything was dark.

The next thing I saw was Saint Peter, welcoming me into heaven.

Or at least that's what I thought until the saint blasted a flashlight in my eye and an annoying beeping blared in my ear. They later told me that as we pulled into the hospital driveway, I went into cardiac arrest and my heart stopped. As they rushed me into the emergency room, the attending physician pulled Susan aside and told her it was a good idea to call our family because even if they could resuscitate me, it probably wouldn't last.

"He might not make it to see the morning," he informed her.

All night, I slipped in and out of consciousness. Lord only knows what kind of drugs they were pumping through me, so I don't remember much of the time in the emergency room. Susan said we were there several hours before they finally, against all odds, stabilized me.

The hospital didn't have private rooms back then, so as I recovered over the next few days, I got to know the patient in the next bed very well.

He was an agent of some sort. I don't think I ever knew what kind. This town is full of them. If you see a man in Hollywood wearing a tie, he's most likely an agent. Or a mortician, but even then, he's likely to try to sell you a script or an up-and-coming actor while hawking coffins.

This guy was in his early fifties and very tan. And he had a very, well, let's say *noticeable* girlfriend. She was well under half his age with permed, bleached blond hair, a tan as bronzed as an ancient Roman urn, and a pair of tortiseshell sunglasses always perched on top of her head. Sometimes she wore a yellow sundress; other days she came in wearing a T-shirt and ripped blue jeans that looked like they had been run through a garbage disposal.

Each day, she pranced into the room in her sunglasses and cooed over the agent while he was awake. As soon as he fell asleep, she disappeared to who knows where in the hospital. But as if notified by some secret intercom, the second he awoke, she was back by his side, fluffing pillows and calling him baby.

One of the worst parts of being in a hospital is the constant prodding and checking and observing and taking of your temperature, blood pressure, and pulse. You end up feeling like the unlucky turkey being poked by an eager housewife preparing her first Thanksgiving dinner. But by the second or third day, the agent and I had identified a lull in the schedule, when the nursing staff changed shifts. We probably had a good solid hour without someone coming in the room to bother either of us.

So the next day, during the shift change, the girlfriend strolled into the room twirling a small pink purse in her hand. She shut the door and pulled the curtain between me and the agent as far as it would extend.

215

"Hope you don't mind, buddy," the agent said. "But I'm dying here. I gotta get some relief."

And let me tell you, men released from solitary confinement in a prison after a decade probably don't carry on with women the way that agent did. I never asked him what condition brought him to the hospital. But judging from his exertions with that girl, his heart was obviously pumping just fine. Thankfully, the agent was released after a couple more days so I didn't have to put up with too many episodes of Dr. Strangelove.

All total, I spent nine days in the hospital recovering from my heart scare. Nurses and doctors congregated in my room during their breaks, asking to hear stories and jokes. Sometimes they came in with their shoulders slumped, and collapsed in the chair by my bed because they were exhausted or had just lost a patient. And I listened to them as they talked about their shifts.

In spite of being highly trained medical professionals, in spite of the fancy cars the surgeons drove, in spite of the horrors that the trauma team saw, they were really no different than the children that came to *The Bozo Show* each day. These doctors just wanted to be able to rely on an old pal.

The day after I was released, Susan and I went for a walk. It's a simple thing, taking a stroll with your spouse. But the fact is that we'd never done such a thing before. We worked from the minute we woke up in the morning to the time we went to sleep at night. Even on so-called vacations, we toiled away on merchandise agreements, scheduling appearances, and contracts. On a getaway to Laguna Beach, Susan and I left the "Do Not Disturb" sign on the door all hours of the day. Evidently, this was so rare that the general manager came up to check on us.

"What do you do in there?" he asked. "I'd like to be doing that with my wife!"

The simple answer was that we were working.

But when we were signing out of the hospital, the doctors advised me to get some light exercise. So Susan and I walked a few blocks down the street from our apartment to the Fairburn Avenue School. We watched kids run in the playground and climb the jungle gym. We turned west on Rochester and looked at the nice homes and manicured lawns. Under a tree near the sidewalk, I noticed a small purple wildflower and I bent down to pick it. It was the first time in my life that I'd lived the old adage of stopping to smell the flowers. I don't know what variety of plant that little wildflower was, but it smelled sweeter than the most expensive rose in the best floral shop in Beverly Hills.

Those first few days were frightening. I felt incredibly fragile, like I would break if I bumped into a table or pop like a punctured balloon if I touched anything sharp. In the process of almost dying, I had become afraid to live.

But the folks at my office needed me. There was Bozo business to attend to. There were people to entertain. So I slowly but surely started to push myself. Those early evening walks with Susan got longer and longer. I did more work around the house. And I began to recall that I wasn't made of handblown glass. I wasn't going to shatter. I was the same man who had trekked through jungles, welded ships underwater, trained to be an astronaut, fought a python, and faced a batter for the Cleveland Indians. My whole life had been dominated by a fearless attitude to try, do, experience, and share anything and everything because I believed nothing was impossible.

So at dinner, I told Susan I was going to the office in the morning. "Plan for a long day," I said.

When I opened the office door, I was shocked at the avalanche of mail, contracts, orders, fan letters, and requests that had poured in during the time I had been sick. My office looked like a paper warehouse had exploded.

As I unearthed my chair and got to work, my heart felt like it would burst—but from happiness, not illness. I had been cooped up for too long. Working on my entertainment business, I felt like a racehorse finally released from the starting gate. It was a tremendous rush of energy and creativity and excitement. And I realized medical conditions might slow me down now and again, but they couldn't prevent me from marching forward and achieving my dreams.

Over the years since then, this old ticker of mine has given me a fair amount of grief. In addition to the cardiac arrest, I've had two heart attacks, ventricular fibrillation, atrial fibrillation, six angioplasties, three stents, and congestive heart failure three times. But I don't let it get to me. I've been through it all and I'm still here laughing.

One of the reasons I'm able to do that is because of an experience I had that day back in 1985. On that first day at work, when I looked up, it was early evening and the sun was setting outside. Immersed in my mountain of paperwork, I'd been unaware of the hours passing. I yelled into the other room to ask Susan what she wanted for dinner and then called downstairs to order some Thai delivery. After a few minutes, I got up from the desk and walked over to the window. During my time in the hospital and in the days after my release, I had grown a beard. I absentmindedly rubbed the hair on my chin as I looked through the wall of glass.

At the time, my office was at Raleigh Studios, a hustling hotbed of entertainment and action. Over the years, I had stood in that window and watched more film shoots and publicity stunts than a boy from Cleveland had any right to even dream about. That office window was my porthole to the industry, constructed with hard work, dedication, creativity, and a few tons of white makeup.

"There's even more mail," Susan said as she walked in the room, carrying an overflowing box. "There are some documents

in Portuguese regarding the Brazilian show. We'll have to get those translated. It just amazes me that this stuff doesn't stop or slow down, even when you're in the hospital, scaring us all half to death."

"No one has a clue, do they?" I said.

The buzzer sounded and, as Susan went out to pay the delivery guy for our dinner, I turned from the window and looked at the box of mail she had left on the floor. There was every kind of envelope sticking out of it—hand-addressed and decorated envelopes from children, official-looking manila envelopes, red-striped envelopes sent by international airmail. I had been given a death prediction and yet the business of Bozo—the love of Bozo—had continued without missing a beat.

At sixty years old, I had made my dreams come true. I had fashioned this character into an icon that would survive whether or not I was here. Kids in Brazil didn't know and didn't care that I had been in the hospital. All they knew was that they could still count on their old pal Bozo.

Susan brought in our dinner and we sat at a conference table and watched the sky turn burnt orange and then fade to darkness over Los Angeles as we ate. When we were finished, she asked if I was ready to go home.

"No, not yet," I said. "There's more work to do."

AFTER**WORD**

By Thomas Scott McKenzie

I DIDN'T KNOW WHAT HE LOOKED LIKE, BUT WHEN I STEPPED INTO THE DARK RESTAURANT, I IMMEDIATELY KNEW EXACTLY WHICH MAN WAS LARRY HARMON. HAD I LOOKED CLOSER AT THE DINERS THAT EVENING, I WOULD HAVE PICKED HIM OUT BECAUSE OF THE BOZO WATCH ON HIS WRIST. BUT I DIDN'T HAVE TO EXAMINE THE SCENE THAT CLOSELY. I JUST LOOKED FOR THE MAN WITH **THE BIGGEST SMILE IN THE ROOM.**

Throughout the meal, he shared amazing story after amazing story. Each one better, and more hilarious, than the rest. He periodically gave me a break so I could catch my breath as he said hello to a member of the restaurant staff or someone at a nearby table. Larry spoke several languages and knew everyone in town, so dining out included a constant stream of chats and hellos to anyone who came within earshot. I understood now why people thought he should run for office. I hadn't met anyone better known and better liked.

In the coming weeks and months, as Larry shared his stories with me, we got into a habit of spending long Sunday afternoons on the phone. He told his amazing tales, pausing to expand on his philosophy of success, hard work, and overcoming the odds. There were times when my ear felt like it would burst into flames from the burning hot telephone and my shoulder ached from cradling it for hours. But I never wanted to miss a single tidbit or a solitary piece of advice.

I didn't get to know my grandfathers as well as I would have liked. Early heart attacks and long distances cut short our relationships. But when talking to Larry, I felt like I was tapping into a deep well of experience and finally receiving the stories, lessons,

and insights that I had missed in my own life. Over the months, I even made some major career changes because Larry became such a strong role model of taking chances and being unafraid. He was inspiring, entertaining, educational, caring, and each week, I looked more and more forward to our phone calls.

The writer Mitch Albom may have had *Tuesdays with Morrie*, but I had something better: Sundays with Bozo.

Larry Harmon seemed to have done everything there is to do in life. He had worked so many jobs, accomplished so much, and interacted with so many famous people. I became convinced that if I mentioned Genghis Khan, Peter Pan, the Barber of Seville, and Amelia Earhart, he would have a story about playing bridge with them.

And just when I began to doubt a story because it was so incredible, he or his wife Susan would present me with proof: photos of New Guinea, *Time* magazine coverage of his presidential campaign announcement, and video footage of deep-sea diving, fireman training, the vomit comet experience, and on and on.

Sometimes I would press him in our interviews and challenge what he said, but, deep inside, I knew I wasn't investigating shady financial dealings at Enron or how much the White House knew about weapons of mass destruction before invading Iraq. This wasn't life or death, just happiness and fun. So most of the time, I sat back and just enjoyed the stories. And, ultimately, that's what this book is all about: pure enjoyment.

Clearly, certain adventures were watershed events in Larry's life. So his trip to New Guinea, the presidential campaign, and spending time in zero gravity came up first when we began talking. But scattered throughout every conversation were small references that hinted at yet another incredible story. Like the time he mentioned Chiang Kai-shek while we discussed the spread of *The Bozo Show* around the globe or when he referenced a Charles de Gaulle

memory as we chatted about Fred Astaire. I would jot down the references to remind myself to get more details from him during a later conversation.

Over the months, people told me that Larry's health wasn't good. Yet I never would have known it from the time we spent together. Whenever I was in Los Angeles, he always made it out to share a meal or meet me at his office. He always had the same excess of energy, vitality, and desire to achieve. However he might have felt, he was always eager to help or teach.

"Hopefully, they'll have a better medication when you reach this point," he told me. "But, as a heads up, this Flomax stuff makes your nose run like a faucet. If you ever have to take it, be sure to keep lots of tissues handy."

He never complained about taking the medicine himself. He didn't gripe about his runny nose. Instead, he was thinking of my well-being and future. Even if that future was a few decades away for me.

Unfortunately, Larry didn't have that much time himself. He might have known what was coming, but he didn't let it deter him. He barreled ahead with life, adventures, and plans as though nothing could ever stop him. He had many fanciful projects in the works, and was far from finished spreading Bozo's love. He even had plans to create a few primetime shows percolating in his head. Admittedly, some of these ideas seemed a bit far-fetched when I first heard them. But I always caught myself and switched from skepticism to belief. He had accomplished so much, overcome so many odds, and convinced so many doubters that there was no way you could totally count him out. If Larry Harmon told me he was planning a variety show to take place on the surface of the sun featuring dancing snowmen, it wouldn't have been too hard to accept.

On July 3, 2008, I went to check my e-mail for the last time before the holiday weekend. I quickly glanced at CNN's homepage

before entering the URL for my e-mail account and saw a head-line that asked viewers to share their Bozo memories. That's pretty cool, I thought. I wonder what prompted that?

I went to my e-mail and deleted all the usual offers to increase my manhood, my bank account, and my miles-per-gallon. But something about that CNN article made me uneasy and I returned to the news website. Above the headline I had seen soliciting memories was this entry:

Bozo Actor Dead at 83

Suddenly, the long holiday weekend seemed empty and point-less and utterly sad. And I wondered how I would spend my Sunday afternoons.

It took a while before I could go through the notes and listen to the tapes of our chats. The historian in me lamented all the material we *didn't* get to—all those hints and asides and casual references that were the keys to so many fantastic tales. What's in this book is only an introduction, but it's more than enough to show the adventures Larry Harmon had and the stories he told. And by sharing his sto-ries, we can inspire, generate, and create some of our own.

I'm told that on the morning Larry died, he was talking about work with his usual excitement and energy. And that doesn't sur-prise me in the least. I had spoken to him on the phone just a few days prior to his passing. As always, his voice boomed over the line as he told jokes, did impersonations, and spoke in various dialects and accents to make me laugh.

For someone who'd stuttered as a child and was in danger of being held back in elementary school to become world famous for his voice, speech, and laughter, Larry Harmon did all right in his time on this Earth. He made millions laugh and was an old pal to generations of people across the globe.

About four months after Larry passed away, I was in one of those massive Halloween stores that sprout up in strip malls during

the late fall. I couldn't decide what to purchase as I wandered the aisles, watching kids fight over props such as severed fingers and bulging eyeballs. Then I turned a corner and there, at the end of an aisle, was a Bozo the Clown costume.

Later that evening, as I struggled to apply that famous makeup, I thought about how much Larry had enjoyed teaching me the tricks of the trade. I pulled the wig over my head and lined it up, using the high-arching eyebrows as a guide.

My city had blocked off several major streets in the neighborhood for a massive Halloween party. The paper said thousands of people were expected to turn out. As my friends and I walked to the event, every few steps some fellow reveler would yell excitedly, "Bozo!"

The party was in a hip, artsy neighborhood with a bit of an edge. So there were dozens of slutty cheerleaders/policewomen/angels/librarians, a handful of gory psycho killers, a few crude priests, and a linebacker-sized man dressed as Smurfette.

But no costume seemed to generate the response my Bozo getup did. All night long, people approached and told me stories of watching the show as a kid. Complete strangers waved and yelled enthusiastic greetings. And Larry was right: no one ever used the word "like." It was always "I love Bozo!"

At home that night, my friends tossed their costumes in the trash or threw them on the floor. I folded mine up and put it in the closet. I placed the Bozo shoes on the shelf, turned out the light, and reflected on just exactly how big a footprint Larry Harmon had left on this world.